PORTRAIT OF AN ART GALLERY

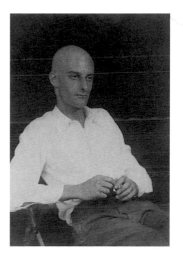

Julien Levy:
Portrait of an Art Gallery

edited by Ingrid Schaffner and Lisa Jacobs

THE MIT PRESS

Cambridge, Massachusetts

London, England

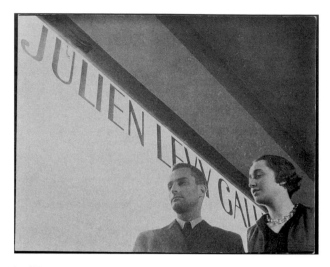

Lee Miller. *Julien and Joella at the first gallery location, 602 Madison Avenue*, 1932.
Collection Joella Levy Bayer.

Coordinators: Pari Stave and Nancy Deihl
Design: Anthony McCall Associates, New York
Composition: Chelsea Arts Inc.
Copy editor: Anna Jardine
Printer: Quebecor MIL Corporation, Toronto
Print production: The Actualizers

Endpapers by Steven Watson

**LIBRARY OF CONGRESS
CATALOGING-IN-PUBLICATION DATA**

Julien Levy : portrait of an art gallery /
edited by Ingrid Schaffner and Lisa Jacobs.
 p. cm.
Includes bibliographical references and index.
 ISBN 0-262-19412-0 (alk. paper)

1. Julien Levy Gallery—History.
2. Levy, Julien.
3. Art dealers—United States—Biography.
I. Schaffner, Ingrid. II. Jacobs, Lisa.

N8660.L47J86 1998
709'.2—dc21 98-15690
[B] CIP

Preceding page: Berenice Abbott. *Portrait of Julien Levy (with Shaved Head)*, 1928.
Collection Jonathan Levy Bayer.

Contents

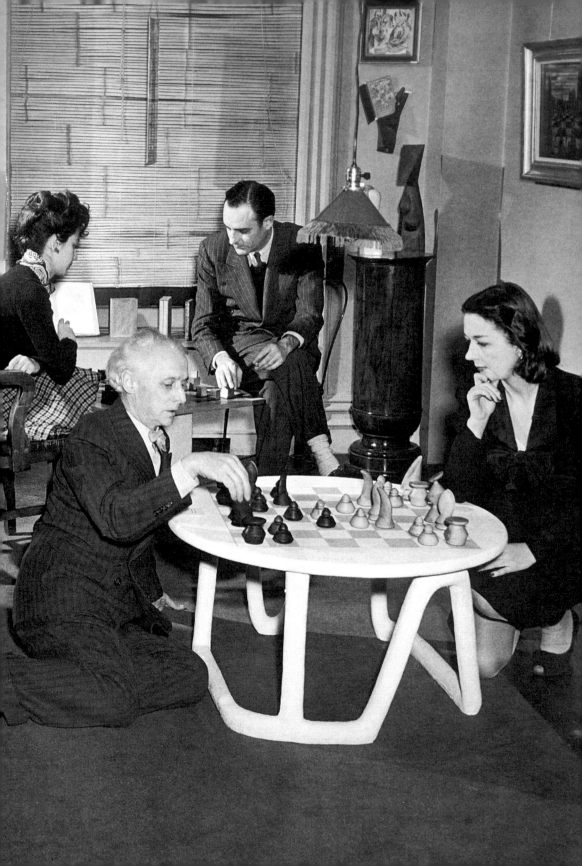

Acknowledgments

First and foremost, we are indebted to Mrs. Jean Levy, whose devotion to Julien endowed our portrait with its unique detail. Indeed, this portrait would not have been possible without her vital enthusiasm and generous support. She opened the doors of The Julien Levy Estate, welcoming us to show its treasures, many of which had never been seen by contemporary viewers. We thank her for sharing her inspiring affection for a remarkable man. Marie Difilippantonio and Miles Borzilleri have assisted us on Mrs. Levy's behalf with encouragement, patience, and kindness, for which we are most grateful.

Julien Levy enjoyed a lifetime surrounded by fascinating people, and we consider ourselves fortunate to have met a few of them. We cherish the days spent with Joella Levy Bayer, Julien's first wife, who graciously provided an essential history (complete with snapshots) of the gallery that she and Julien opened in New York in 1931. We are very grateful to Mrs. Bayer for generously allowing us to read letters Julien wrote to her mother, Mina Loy. Joella and Julien's sons, Jonathan Levy Bayer, Jaaven Bayer, and Jerrold Levy, also shared their memories with us.

In the years we spent researching our subject, we called on many institutions and individuals. Throughout the process, we were sustained by the interest, insights, and answers liberally given by curators, collectors, dealers, librarians, registrars, researchers, archivists, scholars, and Surrealist sympathizers. We owe the following people in particular a debt of gratitude: Ellen Adams, Joe Ascrizzi, the late Pamela Askew, Anna Astner, the late Anna Balakian, Robert Barnes, Geoffrey Batchen, Hendrik Berinson, Rosamond Bernier, Alain Blondel, Adam Boxer, Phyllis Braff, Rudy Burckhardt, Carolyn Burke, Carol Callow, John Canemaker, Henri Cartier-Bresson, Whitney Chadwick, Julie Cho, Susanna Coggleshall, Elaine Lustig Cohen, Billy Copley, the late William Copley, the late Paul Cummings, Keith de Lellis, Sarah

Figure 1. **Max Ernst and Dorothea Tanning playing chess, with Julien and Muriel Levy in the background**

1944. Collection Jean Farley Levy.

d'Harnoncourt, Douglas Dreishspoon, Michael Duncan, Susan Edwards, Amy Ernst, Margaret Finch, Charles Henri Ford, Eugene Gaddis, the late Guillaume Galozzi, Juan Garcia, Beth Gates-Warren, Michael Goodison, David Gray, Nancy Hall-Duncan, Maria Morris Hambourg, Kirsten Hammer, Lynda Roscoe Hartigan, Keith Hartley, Amy Hau, Virginia Heckert, Françoise Heilbrun, Daphne Hellman, Hayden Herrera, Judith Hershman, Howard Hussey, Pamela Johnson, Philip Johnson, Pauline Karpides, Talar Kizirian, Rachel Kunckle, Barbara Lekatsas, Nancy Lieberman, Mary Martin McLaughlin, Norman Mailer, Lee Marks, Raphael Martinez, Steven Robeson Miller, Jane Montgomery, Manuela Mozo, Sune Nordgren, Helaine Pardo, Eleanor Perényi, Mark Polizzotti, Jill Quasha, Howard Read, Alex Reid, Susan Reinhold, Jason Rosenthal, Julie Saul, Naomi Sawelson-Gorse, Rosemarie Scherman and the late David Scherman, Danny Schulman, Cita Scott, Jean Shin, Ann Simpson, David Smith, Sandra Leonard Starr, Edward Sullivan, Michael Sweeney, John Tancock, Dickran Tashjian, Ann Temkin, Yvonne Thomas, Judy Throm, Calvin Tomkins, Leslie Tonkonow, Karole Vail, Beth Venn, Joan Washburn, Steven Watson, Alicia Weber, Howard and Muriel Weingrow, Jonathan Williams, Amy Winter, Joe Wollin, Christina Yang, Virginia Zabriskie, and Armin Zweite.

Bringing together works of art that once passed through Levy's hands was a challenge. The generosity of spirit we encountered from lenders, both to this book and to the exhibition it accompanies, was a tribute to Levy's legacy. In particular, we thank these individuals and institutions: Timothy Baum; Jonathan Levy Bayer; John Bocchieri; Richard Louis Brown; Kristin Nagel Merrill, Pam Stuedemann, and David Travis at The Art Institute of Chicago; Julie Katz at the Chicago Historical Society; Roger Conover of the Mina Loy Literary Estate; Gertrude Dennis of Weyhe Art Books; Claire Copley Eisenberg; Dallas Ernst; Richard L. Feigen; John Huszar of Film America Inc.; Dr. Salomon Grimberg; Lisa Dennison at The Solomon R. Guggenheim Museum; Barbara Kelly at the Howard & Muriel Weingrow Collection of Avant-garde Art and Literature, Hofstra University; Anne Horton; Roz Jacobs;

Mark Kelman; Steve Lucas; Susan Davidson at the Menil Collection; Catherine Curry, Magdalena Dabrowski, Virginia Dodier, Peter Galassi, Steve Higgins, Susan Kismaric, Cora Rosevear, Margit Rowell, and Kirk Varnedoe at The Museum of Modern Art; Robert Rainwater at The New York Public Library; Peter Filardo and Martha Foley at the Tamiment Library at New York University; Joe Jacobs and Mary Sue Sweeney Price at The Newark Museum; Lucy Shelton Caswell at The Ohio State University Cartoon Research Library; Gertrud and Howard Parker; X. Theodore Barber at The Anna-Marie and Stephen Kellen Archives of Parsons School of Design; David Brenman Richardson; Louis Rispoli; Arno Schefler; Howard Stein; Mr. and Mrs. Jerome Stern; Dorothea Tanning; Steve Turner Gallery; Rebecca Lawton, Nancy MacKechnie, and James Mundy at Vassar College; The Wadsworth Atheneum; Thomas Walther; Adam Weinberg at the Whitney Museum of American Art; Helen Miranda Wilson; Patricia Willis at The Beinecke Rare Book and Manuscript Library, Yale University; Judith Young Mallin of the Young-Mallin Archive; and Joseph Zicherman.

We acknowledge the initiative of the American Federation of Arts for developing the original proposal for this project. We warmly thank Anna Jardine for patient editorial guidance, and John Bernstein and Anthony McCall for their perseverance and design expertise. Finally, we express our very deep gratitude to Elizabeth Cacciatore, Nancy Deihl, and Pari Stave of The Equitable Gallery for their commitment to realizing this portrait of the Julien Levy Gallery.

Ingrid Schaffner and Lisa Jacobs
New York City, 1998

Introduction

Ingrid Schaffner and Lisa Jacobs

This book proposes a portrait of the Julien Levy Gallery, a subject that lends focus to one of the most dynamic and yet obscured periods in American art history. Opening in 1931, in the midst of the Depression, and closing in 1949, with the country on the verge of postwar prosperity, Levy's gallery was in operation during precisely those years of transition when the center of the cultural avant-garde moved from Paris to New York, a haven for exiles and later the hub of the new school of Abstract Expressionism. As a champion of Surrealism, experimental film, and photography, Levy was a conduit for some of the most vital aesthetic charges originating in Europe. What his gallery did not represent directly, it touched on, either through Levy's wide range of art world affiliations, or through his enthusiasms in the realms of popular culture, fashion, and entertainment. Because such associations are intrinsic to this consideration of the gallery, its scope is wider than that of a typical portrait—it is populated by many figures, on shifting cultural grounds, and encompasses diverse objects, events, performances, and experiments. It intends not only to portray the Julien Levy Gallery and record its specific history, but also to evoke the dynamism of an age by profiling an influential and impressionable participant.

Julien Levy exhibited as a dealer or owned as a collector the works of art and ephemera examined here. A list of just some of the artists to whom he gave first New York exhibitions demonstrates what a remarkable eye Levy had: Eugene Berman, Henri Cartier-Bresson, Joseph Cornell, Salvador Dalí, Max Ernst, Leonor Fini, Alberto Giacometti, Frida Kahlo, Leonid, René Magritte, Lee Miller, Pavel Tchelitchew. He was known primarily as the most prominent New York dealer for Surrealism, along with its ancillaries Neo-Romanticism and Magic Realism. Levy also presented exhibitions of Cubism, Machine Abstraction, and Social Realism, and veering from orthodox contemporary

art, devoted exhibitions to decorative arts, theater posters, and cartoons.

The first essay in the book, by Ingrid Schaffner, looks at Levy's enterprise as it evolved from combination curiosity shop, curated exhibition space, and crucible of fashion. Since its beginning, the gallery program was a porous one, not limited to a single medium or message. With both hindsight and prescience, the gallery explored culture-at-large, and drew in notable collaborators: Marcel Duchamp suggested ideas for projects; Lincoln Kirstein and Agnes Rindge curated exhibitions; André Breton, Gilbert Seldes, and Edith Sitwell wrote catalogue texts; Schuyler Watts and Russel Wright designed lighting.

Levy exhibited photography as an art form, as had Alfred Stieglitz before him. He opened his gallery with an exhibition of American photography, introduced Eugène Atget and Nadar to New York audiences, showed modern European photographers, and promoted Surrealist photography. The Julien Levy Collection of Photographs at the Art Institute of Chicago testifies to the eclecticism and breadth of his vision, including as it does the historic David Octavius Hill with the classic Paul Strand with the Surrealist Maurice Tabard.

Levy exhibited film as well. In 1932–1933 he served as president of the first Film Society of New York, whose opening program presented a French version of G. W. Pabst's *Die Dreigroschenoper* in the ballroom of the Essex House. At his own gallery he showed avant-garde and experimental films, including Joseph Cornell's *Rose Hobart* and *Goofy Newsreels,* Luis Buñuel's *Un Chien Andalou,* Fernand Léger's *Ballet Mécanique,* and Man Ray's *L'Étoile de Mer.*

The essays by Carolyn Burke and Steven Watson consider Levy's activities from different vantage points: the former deeply personal, the latter concerned with economics and class. Levy may have been quick to adopt

11

Figure 2. **Exhibition announcement** 1932. Collection Jean Farley Levy.

Duchamp and Stieglitz publicly as his "godfathers" in art, but his mother-in-law, Mina Loy, the poet, painter, and bohemian, was his secret muse. She was also, in practical terms, his agent in Paris during the gallery's early years. Burke describes their complex relationship in terms of works of art that Loy helped Levy procure, works that are emblematic of his art dealings.

Watson approaches Levy as a member of that elite group he calls "Harvard modernists," all of them students of Paul Sachs. Sachs's famous course in museum administration at Harvard turned art history buffs into contemporary culturati. They included Alfred H. Barr, Jr., who in 1929 became the first director of the Museum of Modern Art, and Arthur Everett Austin, Jr., who as director of the Wadsworth Atheneum made Hartford, Connecticut, an avant-garde destination during the 1930s. Levy the dealer merchandised what these men institutionalized: modernism as an international style.

This portrait of the gallery is also its scrapbook, with the requisite memorabilia. Complementing the perspectives offered by these essays is a series of snaphots. The first is lovingly composed, from many sittings, by Dorothea Tanning, whose debut solo exhibition was held at Levy's gallery in 1944. The others offer glimpses by friends and colleagues, all of which are pinned to an essential chronology of exhibitions and events at the gallery. It is no coincidence that this construct emulates the composition of one of Levy's most enduring achievements: a proto-history of the movement with which his vision is most closely identified, *Surrealism.* Published in 1936, the book is organized around a series of defining precepts and characters. Our introduction to Julien Levy began with his book, and in arranging the art and

Figure 3. **Isamu Noguchi, *Portrait of Julien Levy*** 1929. Bronze, 20 x 10 inches. Collection Jean Farley Levy.

ephemera represented here, we have borrowed Levy's thematic approach, cribbing headings in homage to his aesthetic.

There is no definitive archive to consult on the Julien Levy Gallery. What little documentation there is has yet to be assembled. But traces can be found: in private and public collections; in contemporary newspapers and magazines; in private papers; and most important, through personal recollections. In attempting to convey as comprehensively as possible the diversity of Levy's exhibition program, we have had to conduct some elaborate detective work. Our first clues were the brochure announcements and occasional checklists that Levy produced for exhibitions, and private correspondence. Letters between Julien Levy and Mina Loy were important and fascinating; they reveal Levy's ambitions, his wit and dreams, his vision and complexity of mind. What emerges from them is a dramatic record of the history and business of the gallery These documents—when we found them—were doorways into further research on the individual artists and titles that would, we hoped, bring us to our goal: objects bearing the essential Julien Levy provenance.

Of course, we encountered many windy corridors that led nowhere. Some passages ended at glass doors, through which we could see, far in the distance, unattainable objects of desire. Other passages ended more obliquely. Who, for example, collected the work of the fashion illustrator known as Milena, cousin of King Alexander of Yugoslavia, who died at the young age of thirty-three? Where were the paintings by Dr. Marion Souchon, artist-surgeon of New Orleans? We still search in vain for even a glimpse of one of the original jewels designed by Salvador Dalí that Levy exhibited in 1941. Or for one of

13

Figure 4. **Julien Levy in his gallery** c. 1939. Collection Jonathan Levy Bayer.

the tantalizingly entitled paintings such as *Man with Mike Fright Moons over Manicurist,* by the comedienne Gracie Allen.

Along the way, we contacted museum curators, private collectors, dealers, artists, acquaintances of Levy's, students, neighbors. A devoted friend of Levy's later years made a key introduction to the Levy Estate, where many treasures lay in store. This cache, much of which is examined here for the first time, has proved invaluable to our study.

Ultimately, our portrait remains unfinished, but it is our hope that we have delineated at least a likeness, through myriad details, of Julien Levy's gallery.

Figure 5. **Max Ernst and Julien Levy at the summer house they shared in Great River, Long Island** 1944.

Collection Jean Farley Levy.

The Julien Levy I Knew

Dorothea Tanning

He not only dwelt in New York, occupied New York, breathed New York, possessed New York. He *was* New York. This was the Julien Levy I knew in the final eight years of his gallery activity. The Julien Levy Gallery had already brought, mostly from France where radical things were happening to art and ideas, a stunning series of visual explosions whose seismic vibrations were felt in studio lofts and galleries all over town and as far away as California. By the time the Museum of Modern Art got around to its famous exhibition *Fantastic Art, Dada, Surrealism* in 1936, the Julien Levy Gallery had given New York four years of surrealist shocks, such as the Dalí exhibition I walked in on one day in 1941, where both Dalí and his wife occupied the place like an invading army. Incidentally, Julien told me later that his first two Dalí exhibitions did not sell even one picture. He would say things like this with consummate irony, but very offhandedly, as if expecting you to know that such is the art dealer's way of life.

Before saying that Julien was sophisticated you would have to define his kind of sophistication. Was he an Ulrich, Musil's sardonic jaded young esthete, or Proust's Swann or even Dorian Gray without the portrait? Fantasies that tumbled in my mind and that would have made him laugh. Yet, his persona was a magnet for adjectives. They swarmed around him, clung to his profile (lovely to draw), hair (shiny and black), silhouette (slim, *gracile*), the ensemble elegant, suave, debonair, elusive, without any of them, or even all of them together, pinning him down. When Walter Pater said, "Art is life seen through a temperament," he was surely anticipating Julien Levy. This temperament gave him the air of an extraterrestrial emissary, fascinated and amazed by everything he saw and heard. And read: the off-beat, the occult, the enigmatic, the happened-on treasure of the day. How natural that he should find in Joseph Cornell a mirror of his own thoughts!

I would like to convey, without effusion and very exactly, my disarray and euphoria in that delicious amalgam those two emotions produce, when the great Julien Levy came to look at my work. Disarray, because there was so little to see. I had stammered my confession about that when he phoned. But he said, "So I'll look at the two and a half." Euphoria because, of all the gallery activity on Fifty-seventh Street, where everything happened in those days, it was the Julien Levy Gallery that was truly making art history, the place where it was "at." The prospect of seeing one's own work on its walls was, well, breathtaking. The day came, and after looking at the "two and a half," Julien said, unbelievably, "From now on you're in my gallery." He paced the studio (my back room). "The first thing is for you to meet some people," he was saying as he strode around. "Next time I have a cocktail I'll call you." Oh, yes!

But weeks, months passed, winter came and went. Of course, I mused sadly, it was too good to be true. Until one spring day and the phone, "I'm having that party. Can you come?"

1942. A May afternoon as only May afternoons can be in the city. And an apartment in Chelsea, all dark wood and those wonderful slatted shutters peculiar to old New York. A Récamier sofa, an iron sleigh-bed breathing Paris, a Bellmer doll, the Duchamp window and scattered, everywhere, objects, pictures, books and more pictures. Indeed, coming in for the first time, you were so overwhelmed with vertigo that it was hard to register Julien's easy, smiling introductions to—as I remember them—Yves Tanguy, Max Ernst, Kurt Seligmann, Kay Sage, Bob Motherwell with beauteous wife Maria, Virgil Thomson, Max Ernst, Consuelo de Saint-Exupéry, Peggy Guggenheim, Sylvia Marlowe, Max Ernst…Doesn't the repetition say it all? Because, quite simply, this was a new door for me to open, and it was Julien Levy who held the key, who did it all, not deliberately—he didn't believe in plans—who very nonchalantly launched my art and found me a life companion.

His gallery? Imagine a house on Fifty-seventh Street, its second "floor-thru" reached by a small elevator. Imagine two handsome rooms with

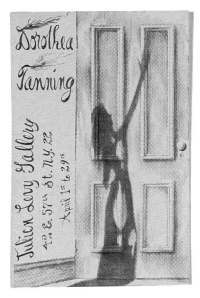

a pretty secretary to match. Here, it seemed, all New York irresistibly came: to look, to listen, to wonder; but alas, rarely to buy. In looking back one sees the confusion. It was all so startlingly unfamiliar, defiant, even confrontational, as one might say today. These were not pictures to graciously fill the spot over the sofa. And Julien Levy was not your familiar art dealer either. He was helpful, he was gentle, he would tell his visitor about the phenomenon called Surrealism and when the elevator door closed would turn, spread his two hands wide, palms up, in helpless bafflement at the departed visitor's— incomprehension? timidity? obtuseness?—But the next minute, exasperation forgotten, would see him telling you something funny, maybe about the very rich collector who bought directly from a certain artist for a *prix d'ami,* a "friend's price," a figure somewhat higher than the gallery's price tag.

Thus, although the Julien Levy Gallery was the place where one could see a new kind of art, Julien himself was much too absorbed in the ongoing drama of Dada and Surrealism—movements that sparked so much of what followed without ever being commercially viable in themselves—to watch for the main chance as a dealer in pictures.

We shared vacation interludes, with our respective mates, dogs, and cat during two Long Island summers, 1944 (Great River) and 1945 (Amagansett), in two of those soulless houses responsible to nothing more substantial than the renters' joy at getting away from the city heat. We braved mosquitoes to grab a tomato in the garden, we caught blowfish down by the water's edge (this first house was on the Sound) and ate their chickeny tails, which Julien pronounced delicious while feeding his portion to the cat;

Figure 6. **Exhibition announcement** 1944. Collection Jean Farley Levy.

we played chess on screened porches, we painted or sculpted. Suddenly absorbed in the creative possibilities of eggshells as molds, Julien made a plaster chess set, full of gentle curves and *rondeurs*—as if to soften the game's ferocity. (Ah, where is it now?) In fact, Julien was dead serious about chess, and as we didn't play with the clock, a single brain-cudgeling *partie* with him could last for days. He had also delved deep into the esoteric sciences, from Buddha to Blavatsky, and knew how to read the tarot. So on rainy days, besides chess playing, there was your future to attend to, with Julien telling the cards as a special favor, solemnly, respectfully, perhaps direly—and only if he thought you could take it seriously!

That summer was the prelude to, or preparation for, his fall exhibition *The Imagery of Chess*. It consisted of a number of chess sets invented by the gallery artists (it included of course, Julien's eggshell creations; and I especially remember Bill Copley's set: tiny bottles of liquor which you were permitted to drink after capturing the piece), as well as objects and paintings. A special feature of the show was an evening of chess in the gallery, with invited guests watching a game of seven players challenging the chess master George Koltanowski, who was blindfolded! With Marcel Duchamp as referee— he called out the moves—ours were all brave chessboards, like doomed rafts, piloted by Julien Levy, Frederick Kiesler, Vittorio Rieti, Alfred Barr, Xanti Schawinsky, Max Ernst, and me, all vanquished except Kiesler who achieved a draw. In chess as in ideas Julien was often benignly monitored by Duchamp, one or two of whose wonderful, enigmatic pieces were always on view in the gallery, where, I may add, Julien gave me my first exhibition (1944).

Back in New York, Julien then lived on Fifty-seventh Street, over the gallery. In his salon—for such it was: dark brown walls, Turkey carpets, golden lamp-lit people, dry martinis, his beautiful wife Muriel—one could superbly ignore those wet November twilights outside the long windows. Here, in this meeting place of novas from many constellations besides art—theater, music, criticism, poetry—I began some of my most enduring friendships,

with people as diverse as George Balanchine, Muriel Streeter Levy, Joseph Cornell, Gypsy Rose Lee, the young Merce Cunningham, and John Cage, to say nothing of the turbulent French Surrealists, who, save for the one I captured, Max Ernst, drifted away like mist at the end of the war.

It is hard now, when the word "surreal" is used for the merest incongruity, to understand the excitement it generated in the art world of that time. If the Julien Levy Gallery was a center of that excitement, perhaps the most excited person there was Julien himself. He had found Dada and Surrealism in Paris and had brought them home like trophies to New York. But his real reward was the discovery of more of the same signs at home: Arshile Gorky, with the sadness of the world permanently upon him; Joseph Cornell, pale and intense; the brothers Eugene Berman and Leonid, both drenched in nostalgia. All of them (and many more) under Julien's wing, on Julien's walls, in Julien's pantheon of treasured artists along with the already famous.

Far stronger than the art dealer's temporal sponsorship of a new trend in painting was Julien's commitment to what he saw as an irresistible blueprint for psychic adventure. With his avid research, his translations from the French, and especially his own writing, he ranged himself on the side of ideas rather than that of commercialism, and thus was really only a part-time art dealer. Seeing this, it came not as a surprise but simply as the end of something enchanting, heroic, and irreplaceable when, in 1949, the Julien Levy Gallery closed its doors. I, for one, thank him, wherever he is, for having counted me in.

Alchemy of the Gallery

Ingrid Schaffner

I love stupid paintings, decorated transoms, stage sets, carnival booths, popular
engravings, old fashioned literature, erotic books with non-existent spelling,
the novels of our old grandmothers, fairytales, children's books, old operas, silly
refrains and naive rhythms.

> —Arthur Rimbaud, *Alchemy of the Verb,* 1873 (translated by John Ashbery)

Gallery-hoppers once made beelines to the Julien Levy Gallery. It was *the*
place to see advanced contemporary art, according to the collector
and Museum of Modern Art curator James Thrall Soby. As Soby reminisced
in his unpublished memoirs: "[Julien Levy] was for a long time the only New
York dealer who handled the work of the Surrealists and Neo-Romantics.…
Nor did he neglect some of the best younger American painters, sculptors and
(a very rare inclusion in the early 1930s in New York) photographers. It was
at his various galleries in the 57th street area that I first saw the paintings of
Ben Shahn, the photographs of Atget and Walker Evans and of many other
artists whose names now seem secure in art's ever-changing constellation."[1]
Upon arriving in New York from Paris in 1941, Leo Castelli recounted, he
"immediately got involved with people who were, like me, interested in the
Surrealists, who were very fashionable, the latest thing."[2] At the top of his list
was Julien Levy.

In October 1937, the gallery opened at the second of the four
locations it would have during its eighteen years in New York. Leading into
the space was a magnificent curved wall, "the shape of a painter's palette."[3]
Vogue enthused: "The newly-planned walls are broken up artfully, dipping
and waving and straightening out again. The rug is dark wine, the walls white,
the effect naked and modern."[4] Pictures hanging on those walls took on a

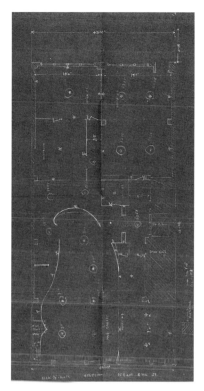

cinematic sequencing, directed by the dealer. Accelerated by the viewer's advance, the curve rapidly dissolved one image into another, like frames in a film screened through a projector. A gallery press release announced that pictures "present themselves one by one, instead of stiffly regimented as they would be on a straight wall."[5]

Films and photography had been regular features at the gallery's first location. Not classic American photography— moments frozen on the straight side of realism—but rather an avant-garde and European aesthetic. Levy's taste was experimental, the images he chose often blurred by passages of movement and time, the very properties of cinema. Since his college days, the movies were Levy's first love: in 1927 he sailed across the Atlantic with Marcel Duchamp, intent on making a film with Man Ray. And in 1941, lured by the siren call of Hollywood, he took his gallery on the road with a "caravan" series of exhibitions for a season on the West Coast. In a cast that over the years included Joseph Cornell, Salvador Dalí, Max Ernst, Alberto Giacometti, Frida Kahlo, René Magritte, and Dorothea Tanning, who all debuted in New York at Levy's gallery, the star of the gallery's final location was one of Surrealism's most decisive harbingers of Abstract Expressionism, Arshile Gorky.

In light of its contemporary reputation and this montage of achievements, Levy's enterprise during the 1930s and early 1940s can be seen to anticipate the great New York art galleries of the late 1940s and the 1950s,

Figure 7. **Architect's blueprint showing the curved wall for the Julien Levy Gallery's second location,** at 15 East Fifty-seventh Street. 1937. Collection Jean Farley Levy.

those under the direction of such dealers as Sidney Janis, Sam Kootz, and Betty Parsons. In league with Peggy Guggenheim, Pierre Matisse, and Curt Valentine, Levy promoted the European avant-garde and Internationalism in America; his successors, in turn, promoted an American school of art, Abstract Expressionism, to an international audience of museum directors, collectors, connoisseurs, and critics. What *Vogue* admired in 1938 as Julien Levy's stylishly modern good taste in white walls became the de rigueur backdrop for serious painting and sculpture. Betty Parsons recalled the stark white interior of her gallery when it opened in 1946: "In those days galleries mostly had velvet walls and very Victorian decoration. I decided to hell with all that....When you're showing a large painting by Jackson Pollock, the last thing the work needs is a plush velvet wall behind it."[6] Levy codified the rituals of contemporary gallery commerce, from sending out press releases and snappy announcement cards, to throwing opening-night cocktail parties. The gallery routinely published brochures with essays by famous writers and critics, who established an instant context for an artist's works. Levy created a buzz that attracted the smart set, collectors, curators, press, other artists, who then generated reviews, gossip, speculation, and—most significant for the artists whose work was on view—interest and sales. In short, the Julien Levy Gallery made art lively.

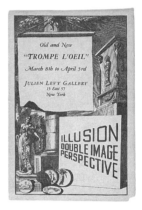

But it wasn't all famous names and tasteful surroundings. There emerges another image of the gallery, this one less modern, *retardataire* even. For each naked white wall, Levy's gallery also had its scarlet side, with a "Harvard red room which took the place of red velvet....I've always kept that color for painting."[7] In such a room, Levy would show old American theatrical posters, American folk art, drawings for interiors by design students, costume designs for the ballet, and would sell books and periodicals.

Figure 8. **Exhibition announcement** 1932. Collection Jean Farley Levy.

In pursuit of commercial opportunities for his artists and himself, he kept portfolios of portrait photography with hopes of landing paying sitters. He sought mural commissions for decorative interiors by his artists. He even offered a line of his own photo objects, trompe-l'oeil wastebaskets and lampshades.

These "kinick kinacks," as Levy called them, hark back to the historic origins of art dealing, to the curiosity shop and antiques trade. An eighteenth-century French dealer's card exemplifies the diversity of interests that captivated early collectors:

> M. Gersaint, jewelry merchant...sells all of the latest metalwares and objects of taste, Jewels, mirrors, cabinet paintings, pagodas, Japanese lacquerware and porcelain, seashells and other artifacts of natural history, pebbles, agates, and all kinds of strange and curious merchandise in general, in Paris, 1740.[8]

Two hundred fifty years later, this bricolage of bric-a-brac seems closer to the *marché aux puces* than to the Leo Castelli Gallery.[9] But for Julien Levy in the 1930s and 1940s, such a display was evidently surreal. And although he may not have gone so far as to deal in bijoux and bibelots, he did show the work of Joseph Cornell, whose collage boxes are filled, like miniature *Wunderkammern*, with just such a world of "strange and curious" things.

Levy's was quintessentially a Surrealist sensibility, undivided in its affections for high and low art and artifacts. As Soby remarked, "Indeed he was as close to being an official Surrealist himself as one could come without signing one of André Breton's guidelines to the Surrealist faith."[10] But Levy's personal identification with the French art movement does not fully explain the paradoxical position of his gallery. Simultaneously forward- and

backward-looking, the gallery is emblematic of shifts taking place in the art world and in art commerce just before the boom of the American postwar period. This essay will consider Levy as both a singular and a representative art dealer in America between 1931 and 1949, when galleries changed from upholstered enclaves and salon-style sanctuaries to fashionable forums with an expanded public, when contemporary artists began to have the cachet of old masters, and when dealers gained new authority within a system of showing and selling directly related to museum collecting and exhibiting. It will also consider Levy's particular affinities, ambitions, and legacy, and what made his enterprise unique.

THE ECONOMY OF ART DEALING

Like the rest of the economy during the early 1930s, the American art market was in a depression. In August 1931, just months before the Julien Levy Gallery opened, *The Art News* reported rhetorically: "Today there is a slump in the art trade of Great Britain and America brought about by large numbers of collectors who are in the habit of buying art [who are] temporarily ceasing to make purchases."[11] An art gallery is by nature an expensive proposition. Aside from its dealing in luxuries, there is the basic cost of rent. Here, Levy had an indisputable advantage in that his father, Edgar, was a powerful New York real estate developer, who during the Depression had many primary locations available to let. On April 3, 1931, Julien wrote to his mother-in-law, Mina Loy, who would serve as his Paris agent during the first years of his gallery: "I have found a beautiful location, size about 20 feet x 50 feet, with a good show window, very bon marché because of the depression, and I am on the point of signing the lease."[12]

Having secured a space, the dealer pays the cost of shipping, insuring, framing, if not outright buying works of art, and then of photographing, and printing announcements, catalogues, and press releases. On top of this, there are the "optional" expenses of a gallery assistant's salary, opening-night

parties, artists' stipends, and professional fees for outside writers and curators. From sales income, the dealer stands to make fifty percent if the work comes directly from the artist, but only a portion of that if another dealer is involved. Although no comprehensive gallery records survive, it seems that Levy's policy was to collect from the artist a work from each exhibition for his private collection, in addition to which he frequently purchased another work or two.[13] When, as in the case of Alberto Giacometti and René Magritte, there were few other sales, Levy would be his own best client.

Price tags from the 1930s indicate that the business prospects for the Julien Levy Gallery could not have been less auspicious. An insurance checklist from Levy for loans to the Harvard Society for Contemporary Art in January 1932 values Atget photographs at $10 apiece, Moholy-Nagy photographs at $15, an Ernst painting at $250, and a Dalí at $450. The high end of Levy's market was represented by Picasso —two tiny paintings at $1,800 each—and Pierre Roy—a $1,500 painting—which Levy had on consignment from other galleries. In the best of times, Levy's income from any of these sales would have been nominal. With the market in recession, a gallery specializing in contemporary art seems to have been an insupportable venture.

And yet it was a time for wealthy young men to embark on visionary ventures. Alfred H. Barr, Jr., was the first acting director of the Museum of Modern Art; Arthur Everett ("Chick") Austin, Jr., as director of the Wadsworth Atheneum in Hartford, established the Avery Memorial Wing for modern art, music, and performance; Lincoln Kirstein founded the School of American Ballet. All were expressing ambitions to institute the avant-garde in America. Even the Whitney Studio Club changed its identity, becoming the Whitney Museum of American Art in 1931. As reactions against the old cultural establishment, with its spectacularly failed investment in the status quo, these efforts might even be seen as an extension of New Deal aspirations. At the very least they indicate how opportune it was to try something new, perhaps because there was so little to lose. By his own account, Levy, a young man

from New York's upper middle class who had been happily seduced from the family business by bohemia, was in it for fame.

ATGET AND AMBITION

Julien Levy's first inklings of becoming an art dealer can be traced to one body of work, the golden-toned photographs of turn-of-the-century Paris by Jean-Eugène-Auguste Atget. "You remember the photos?" Levy wrote to Mina Loy on March 12, 1930. "Of every concievable [sic] subject in or around Paris, doorways, stairways, brothels, courts, trees, street vendors, fairs, shop windows, corsets and umbrellas. All taken with beautiful quality, selection, and composition." Levy had been introduced to Atget during his 1927 Paris trip through Man Ray, who lived near the photographer. At the time, Levy purchased as many prints as Atget would sell, and as many as he could ferret out at antiquarian booksellers'. In 1930, Levy suddenly had more Atgets than he knew what to do with, having just acquired a partial interest in Berenice Abbott's archive of more than ten thousand prints and nearly two thousand glass-plate negatives.

After the photographer's death in August 1927, Abbott, who had been Man Ray's assistant, rescued Atget's oeuvre from the proverbial dustbin of history by acquiring all of the material that remained in the studio from Atget's friend André Calmette. One of her first projects with the material was to coordinate a monograph in French on Atget, which she brought with her to New York in 1930. Levy was then working as an assistant to Carl Zigrosser in the upstairs print room at the Weyhe Gallery, and presumably because of his established interest in the work, Abbott took the book to him in hopes

Figure 10. **Front cover of Jean-Eugène-Auguste Atget's photograph album *Jardin des Tuileries*** n.d. Collection Jean Farley Levy.

of finding an American publisher. She got that, and more, according to Levy's news to Loy:

> [Berenice] will tell you that I have arranged an exhibition for next year of her Atget photos. And I have also bought a part interest in them. They will be hard to exploit as the public in America is decidedly not photo-minded, but I think they are very beautiful, the kind of work of genius that doesn't appear every day, and the problem of managing them to the best advantage will mean two years fun at least. And if they are half as successful as they deserve to be, my reputation as a person, a connoisseur, an art dealer, man in public life, etc. will be made. Also Berenice's reputation as a photographer will be more than merely boosted, and she should make a tidy sum of money. IF they are half as successful as they desrve [sic] to be.[14]

In Levy, Abbott found the support to secure financially the Atget archive that was in her keeping. As a photographer, she had already assumed the artistic charge that she would maintain over the archive, organizing the material, making prints, and storing the glass negatives. She further expressed her deep affinity for Atget by lecturing extensively on his work and, even more explicitly, by undertaking in 1929 a project to document Manhattan, as he had Paris, in photographs. Through Abbott, Levy had found the start of a career, and he set out to make his mark as a New York art dealer representing the work of Atget.

As detailed in his correspondence with Loy, Levy's experience coordinating the Atget show at the Weyhe Gallery is a preview of coming attractions, expectations, and disappointments at the future Julien Levy Gallery. The summer he spent making selections for the Weyhe exhibition was a period of intense fulfillment, of rapturous engagement. What familiarity he had with Atget's work promptly developed into greater intimacy; he "cheated" on his wife, Joella, who was living in Scarsdale until the young couple's New York apartment was renovated, to "work at [the photographs] evenings, staying in town overnight about twice every week. Always discovering new and exciting

ones."[15] To his mother-in-law, he happily confessed, "My photographs are giving me a heavenly summer.... There is nothing I could ask for better than to roll myself between sheets of Atgets, each new one I find (and there are thousands) is a revelation."[16] Years later, when an interviewer suggested that Atget was essentially a Romantic, Levy snapped to the defense of his first love in photography: "I don't know whether you mean it in an insulting way or what"; but he conceded that Atget "probably was."[17] Levy then proceeded to describe with vivid clarity "this monumental effect, in nothingness," in Atget's original prints, as he had come to know them more than forty years before.

At Weyhe, while arranging the photographs along the bookshelves, Levy found the prints as "beautiful [as] most paintings," if not more so. But seeking to promote the work in advance of the exhibition led to one of Levy's first professional disappointments. The editors at *Hound and Horn,* the literary magazine founded by Lincoln Kirstein, were enthusiastic. Unfortunately, however, as Levy explained to Loy, "when Mr. Kirstein heard of the project he flatly said NO. He had only just then decided that nothing but American contributions would be accepted in the future."[18] Levy did manage to place Atget's work in Ezra Pound's literary magazine *Pagany.*[19] The next sign that selling French photographs in America was not going to be easy came from the Museum of Modern Art. During the summer, Levy feverishly fantasized to Loy of Atget's incipient fame: "Even if I am left without one in my possession, I dream of saying 20 years hence 'I once had them all alone in my room, and now they can only be seen in a Museum (or morgue).'"[20] Alfred Barr shared Levy's admiration for Atget and advocated photography as an art in its own right, worthy of museum exhibition and collection. And yet early autumn found Levy faced with a cooler reality. He wrote Loy, "The only set-back being that the trustees of the great Museum of Modern Art have refused photography in general as art. Had counted on a promise from the director to show my Atgets. And that cursed museum has come to dictate the taste in contemporania of most of N.Y. and even of Am.U.S."[21] In 1969 the same "cursed

museum" would purchase the entire Abbott–Levy collection of Atget's negatives and photographs.

Impatient for some evidence of recognition, while constructing dream galleries in the air, Levy joked to Loy, "I am perpetually irritated that things take three or four days to materialize. As soon as I think of the project it should be done, rise whole and sweet from the mental energy I generate. I am already spending the money we haven't gottened, and tomorrow I will be a suicide because nobody comes into the gallery we haven't yet gottened."[22] His reluctance to develop a project, to nurture an artist's reputation over time, would prove among Levy's foremost professional liabilities. As a dealer, he was too often ready to lose interest in those things that did not garner instant support, as Atget's photographs did not. Where his vision was radically ahead of the market, Levy succeeded as a collector, not a dealer. After two early shows at his gallery failed to popularize Atget's prints, they were essentially consigned to storage. (This would be a source of bitterness for Abbott, whose active and steadfast responsibility toward the work led to its sale to the Museum of Modern Art; she resented having to share the proceeds with Levy.[23]) Such was the fate of photography in general, which was soon supplanted by painting and sculpture as the Levy Gallery's focus. Unlike Alfred Stieglitz, for example, Levy was unable or unwilling to commit himself to the long-term project of preaching, proselytizing, and performing the little miracles that it takes to challenge resistance, alter perceptions, and create public acceptance of new art. He experienced a rush of irritation toward potential Atget customers, as he told Loy: "Everybody admires [Atget's photographs] but nobody seems willing to pay a price for one. The feeling is that any photograph is just a snapshot and only worth its association value, no more than that. If you concieve [*sic*] of a promising sales program, do communicate."[24]

It was not all dark premonitions. Although he was not as successful as he had hoped, Levy did experience the first thrill of sales in his introductory exhibit of Atget's work. In late July, even before the Weyhe show

officially opened, he boasted to Loy that "the first primed and mounted speci-
mens were delivered to me here at the gallery, and within an hour I had sold
10 TEN, to two utter strangers (or almost utter)."[25] Midway through the
exhibition, he reported: "This week we received rather good publicity and the
photographs have begun to boom. I have made back all expenses in the two
weeks, no profits yet, but expect sales to multiply as the days go on, and that
will be all profit as there are no further expenses to expect."[26] There is no
account from Levy tallying the score of the Atget show. By the end of the exhi-
bition, on December 6, he had, according to his correspondence to Loy, at
least broken even, received some good press ("Really of course in these days
of depression praise rather than shekels is the best one should expect") and
made some new connections ("I am having my quota of amusement and meet-
ing many important personages through the exhibition").[27] The experience
buoyed him sufficiently that he could announce to Loy his intention to open a
gallery. On January 2, 1931, less than a month after the Atget show ended, he
wrote: "I enter upon the money my mother left me—Jan. 22 at the age of 25.
I am seriously thinking of taking a chance on my immature inexperience
because the state of affairs is too opportune to pass up. I may invest the money
buying pictures, objects, etc. to stock my destined Arte Shoppe. Perhaps I
may leave Weyhe."

A BID FOR THE FUTURE

Dear Mr. Stieglitz,
Greetings! I have so much to tell you, and to ask you, and many
pictures to show you. I am more anxious for your approval than that
of any man I know.[28]

Shortly after coming into his inheritance, Levy quit Weyhe. He wrote
confidently to Loy on March 16, 1931: "I plan to open a gallery of my own,
called the PLACE OF LEVY....I am concentrating chiefly on photography as

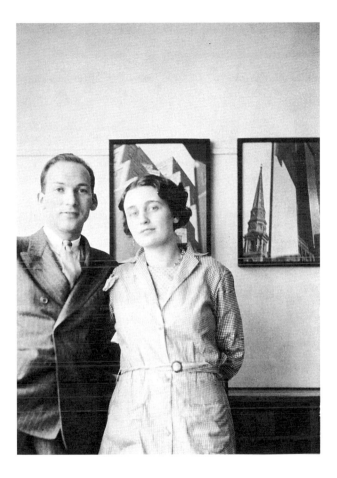

Figure 11. **Joella Levy and gallery assistant Allen Porter** at the 1932 exhibition *Photographs of New York*

by New York Photographers. Collection Joella Levy Bayer.

the 'supreme expression of our epoch' always a secret passion of mine, i.e. any supreme expression, but I am glad to take anything else that may be cornered." And again in April: "I do not plan to have only photographs, but pictures, sculpture, and even kinick kinacks. But photographs are a bid for the future, for uniqueness and publicity."[29] Levy's vision was not unique. Sharing her husband's ambition and informing his plans, Joella Levy encouraged him, in an undated letter, that it was time to act on the opening of a photography gallery. (From her tone, it seems that photo galleries were the rage among the aesthetically inclined of Levy's generation.) She advised him of her choice for the best location—602 Madison Avenue, at Fifty-seventh Street—and urged him to sign the lease.

On November 2, 1931, the Julien Levy Gallery opened at that address, with *American Photography Retrospective Exhibition*. Announced in the brochure as a "concise restatement of work since the daguerreotype," the show was a tribute to New York's high priest of photography and art dealing, Alfred Stieglitz, whose work was displayed along with that of five of his artists. Levy was too young to have experienced Stieglitz's Little Galleries of the Photo-Secession at 291 Fifth Avenue, "291" for short. Between 1905 and 1917, the gallery had hosted a roster of ground-breaking exhibitions: of photographs by Alvin Langdon Coburn, caricatures by Marius de Zayas, New York studies by Francis Picabia. During the late 1920s, however, Levy had made routine visits to Stieglitz's successive spaces, the Intimate Gallery (1925–1929) and An American Place (1929–1946), whose name one cannot help hearing echoed in the mock "Place of Levy."[30]

The interior of Levy's gallery was modeled in part on Stieglitz's immaculate aesthetic. The front room was painted white, but instead of hanging the pictures on plaster walls that would require maintenance after each exhibition, Levy installed an inventive system of wooden moldings designed to hold photographs sandwiched between reusable sheets of glass. This would obviate the costs of framing and touch-up. The back room,

reserved for paintings, was painted red. This touch of the old in the midst of the new perhaps reflects on his previous employment at Weyhe, an altogether different type of gallery. The evenings at Stieglitz's may have been inspirational, but the days at Weyhe provided Levy with practical experience. "It made an apprenticeship for me," he later said of the years he had worked under the print connoisseur and future curator at the Philadelphia Museum of Art, Carl Zigrosser.[31] During Levy's employment at Weyhe, there were shows of woodcuts by Alexander Calder and watercolors by Rockwell Kent; the mainstay there, though, was books.

Books and periodicals played an important role also at Levy's gallery, attracting their own public. Bothered by browsers, gallery assistant Allen Porter interrupted himself in a letter to Agnes Rindge, the Vassar College art historian who was part of the gallery's inner circle of clients and collaborators: "This is all very disjointed on account of I'm here all alone and I have to keep getting up and answering silly questions like are those books for sale. My God, do they think this is an educational institution?"[32] There were buyers. Levy's reputation as a dealer seems to have been as much for art as for books, whose prices at the time were comparable to those of photographs. He sold issues of *La Révolution Surréaliste* ($7.50 a copy) to Harvard University, and poetry and prose to his colleague Pierre Matisse, who purchased Louis Aragon's *Le Paysan de Paris* ($3.00), René Crevel's *Le Clavecin de Diderot* ($2.00), and Paul Éluard's *La Rose Publique* ($2.75).[33] Levy was a distributor for *Minotaure,* the art magazine that launched Skira as a high-end fine-arts publisher. And when Camille Dausse, a physician in Paris who exchanged his services to artists for books, decided to sell his substantial library of Surrealist material, he approached Levy to act as his agent to the Museum of Modern Art.[34]

Stieglitz had diversified interests, too. He was a photographer, an art dealer, and a publisher. (Among Levy's papers was an undated brochure from Weyhe announcing that, in collaboration with Stieglitz, the gallery would carry back issues of his journal *Camera Work*.) For all its personal adaptations,

Levy's opening program and plan remain essentially an homage to Stieglitz. It was wise strategy for the twenty-five-year-old novice to affiliate his enterprise with the established authority in the field. After an exhibition of paintings by the popular portraitist Massimo Campigli (whose sales were intended to compensate for photography's negligible market[35]), Levy presented the historic French photographers Atget and Nadar, both of whom were still little known in America.[36] Atget earned the highest ordination when a reviewer for *The Art Digest* compared his art to Stieglitz's.[37] If Levy's first step as a dealer was to stand on the shoulders of this art world giant, his next several shows marked strides in new directions.

FAME, FASHION, AND FILM

Having staked his opening bid for "uniqueness and publicity" on photography, Levy was granted both, when, in January 1932, his gallery presented the first exhibition of Surrealism—titled in the French, *Surréalisme*—in New York. Featuring painting, sculpture, collage, photography, and books, the show instantly earned the Julien Levy Gallery the distinction of being the place to see sensationally new art. And with the first New York appearance of work by Salvador Dalí, there was publicity galore.[38] Dalí's *Persistence of Memory* was reproduced in virtually every review, with one perplexed critic at *The Art Digest* going so far as to poll New York's psychiatric community: "The limpness of the clocks, one of them found, expressed impotence. Another felt that it was an excellent rendition of potence, because time ... meant

Figure 12. **Salvador Dalí painting a portrait of his wife, Gala** c. 1934. Collection Jean Farley Levy.

power, which could be transformed into anything, even saddles on which one might mount and ride off to victory in the distant hills."[39] Writing on a "bewildering" exhibit, the critic for *The New York Times* demurred: "One of the most entertaining exhibitions of the season (possibly the most profound) is in progress at the Julien Levy Gallery."[40]

The public success of the show gave Levy the fame that he prized over fortune, and plunged the young dealer into activity that turned the next years at the gallery into an extended definition of Surrealism. The course had been inadvertently forecast by Chick Austin, whose *Newer Super-Realism* at the Wadsworth Atheneum was in fact the first exhibition of Surrealism in the United States, having preceded Levy's by two months.[41] Austin asserted: "Sensational, yes, but after all the paintings of our present day must compete with the movie thriller and the scandal sheet," and added, "We do not hesitate to dress in fashion because we fear that next year the mode will alter. . . . These pictures are chic. They are entertaining. They are of the moment."[42] Over the years, Levy's gallery would make art fashionable, and take him to Hollywood.

During the 1930s and 1940s, the arts mixed freely. Perhaps, again, with fewer rewards at stake, artists, dancers, dress designers, and choreographers could risk losing their identities in collaboration. Representative was the 1937 exhibition, organized by Lincoln Kirstein and held at the Levy Gallery, of the Ballet Caravan Collaborators of the School of American Ballet. The exhibition showcased set designs by Paul Cadmus, choreography by Lew Christensen, and music by Paul Bowles and Virgil Thomson; and displayed a Sears, Roebuck catalogue, from which costumes had been ordered, and a seventeenth-century commedia dell'arte engraving, which inspired one dance's imagery of Harlequin. Amid this creative hubbub, one can see the period as a throwback to pre-modern culture, when fewer distinctions separated high from low,

Figure 13. **Exhibition announcement** 1932. Collection Jean Farley Levy.

art from decoration, beauty from pleasure. Austin, for instance, observed the liaison between Surrealism and fashion. Levy also represented the now almost forgotten, but then fantastically popular, Neo-Romantic figurative painters, who merged Picasso's Blue Period with classical de Chirico to conjure an attractive ambience of pathos and ruin. They were also available for mural commissions. Eugene Berman turned James Thrall Soby's dining room into a theatrical setting, an at-home version of a folly at Versailles. The cultural ideals were in many other respects elitist, dictated by young barons such as Kirstein from their privileged, and self-made, posts. For the amount of hybridization, this cultured imagery could even be called baroque. At the same time, the general readership for the arts seems to have been quite sophisticated. Open a contemporary issue of *Harper's Bazaar* or *Vogue* and you will find an essay by Jean-Paul Sartre, models posed in a tableau by de Chirico or photographed by Man Ray, ads for Elsa Schiaparelli designed by Dalí, and items about the Julien Levy Gallery, where there was always something amusing going on.

Where else could you view paintings by Gracie Allen with such titles as *Behind the Before yet Under the Vast Above the World Is in Tears and Tomorrow Is Tuesday,* or *Eyes Adrift as Sardines Wrench at Your Heart Strings?*[43] Where could you shop for prints by Picasso and constructions by Cornell, commission a photographic portrait from Edward Weston, George Platt Lynes, or Lee Miller, and see Frida Kahlo, dressed in full Mexicanista, installing her first exhibition in New York? Where could you buy a Magritte? And when Pavel Tchelitchew's *Phenomena,* a sensational allegory of the contemporary cultural universe, studded with miniature portraits of Gertrude Stein, the poet Charles Henri Ford, and Joella Levy, to name merely a few luminaries, traveled from Paris to London, where did it stop in New York for one week only, but at the Julien Levy Gallery?

Carl Van Vechten, Mr. and Mrs. Nelson Rockefeller, and George Gershwin were among those who RSVP'ed to a private screening of *Un Chien Andalou* held at the gallery on November 17, 1932. This was the second evening

of film hosted by Levy that fall, when he also took office as president of the first Film Society of New York. Modeled after clubs in France, the Society sent out a prospectus in the summer of 1932:

> Beginning in January THE FILM SOCIETY will show to its private membership on one Sunday evening a month...motion pictures of excellence, not ordinarily to be seen even in little playhouses, or forbidden for public performance by the censors, and revivals important to the history of the motion picture.

The first program, held on January 29 of the following year at the Essex House, included an animated color cartoon by Walt Disney, an abstract film of light waves produced by music, and G. W. Pabst's *Die Dreigroschenoper,* in a French version. Four more equally diverse programs appeared through

May, with the American premiere on March 19 of Luis Buñuel's *L'Âge d'Or,* "the first surrealist film of feature length."[44] In preparation for this event, Levy contacted Mina Loy: "If Bunuel gets in touch with you bargain with him.... Impress on him [that] I probably can do better than our offer by renting them to other similar organizations which are in process of appearing like mushrooms these days, and sharing the profits with him." After a successful screening, Levy reported to Loy: "Presenting *L'Age D'Or* was most exciting. We didn't know if our show would be the success of the year, or if we would be run out of town. The former proved true and the film is still the only topic for dinner conversation all about New York."[45]

The Film Society folded after its first season. Levy continued to show artists' films at his gallery, most notably Cornell's *Rose Hobart* and *Goofy Newsreels,* collaged from found footage the artist was buying by the pound from distribution warehouses in New Jersey. The short-lived Society was officially

Figure 14. **Film still from Luis Buñuel and Salvador Dalí's *Un Chien Andalou*** 1929. Collection Jean Farley Levy.

Figure 15. **Film still from Joseph Cornell's *Rose Hobart* (Rose and the Prince of Marudu view the volcano)**

1936. Courtesy Anthology Film Archives, New York.

reincarnated in 1937, when the Museum of Modern Art appointed Iris Barry, founder of the London Film Society and formerly on the board of directors of the New York Film Society, to head its new Film Library; this would eventually become the Museum's Film Department.

MUSEUM VERSUS GALLERY

This progression of events demonstrates the dynamics between gallery and museum. Although Alfred Barr had included both film and photography departments in his preliminary plans for the Museum of Modern Art, his board initially opposed these areas of collecting. One can imagine that the reputation of photography at the Museum was significantly besmirched through association with the ill-fated *Murals by American Painters and Photographers* exhibition of 1932. Organized by Kirstein, who asked Levy to curate the photography section, the show was an invitational that turned disastrous when several advisory committee members resigned in objection to perceived leftist imagery; one contributor, for instance, had "mixed ticker tape with pigs and financiers."[46] Not until 1937 would the Museum seriously broach the subject of photography again, with a major survey curated by Beaumont Newhall. Levy lent several works to the show, which covered much of the ground he had explored in the early years of his gallery.[47]

With his *Surréalisme* of 1932 and many subsequent solo shows of Surrealist artists, Levy's activities laid the groundwork for the Museum of Modern Art's 1936 exhibition *Fantastic Art, Dada, Surrealism*. Compare his New York premieres of Dalí and Tchelitchew in 1933 with the Museum's exhibitions of their work in 1942; his 1933 Cartier-Bresson show with the Museum's 1947 exhibition; his 1945 Gorky show with the Museum's 1962 exhibition; or his 1932 Cornell show with the Museum's 1980 retrospective. The list could go on, as so many of the artists Levy responded to as emerging talents would become the subjects of major museum surveys. But this is the role of a gallery, a fast and light operation with easy access to artists and the work

inside their studios. The ponderous machinery of a museum, with its labyrinth of departments and administrations, its public and fiscal responsibilities, moves slowly and cautiously, and ruminates on what happens in the galleries. Levy, ever outspoken about his aversion to museum bureaucracies, may not have been exaggerating when he said that Barr was "jealous" of his freedom as a dealer.[48] Barr's brilliance was often encumbered and embattled by opposition from inside and outside the museum. When key works in the *Fantastic Art* exhibition were suspected of being communist, for example, Barr had to defend to his colleagues their inclusion in the subsequent tour of the show.[49] On the other hand, a museum has the power and resources to grant an artist the public and historic interest that takes time to establish. And in this respect, although Barr may have envied Levy's independence, Levy would have enjoyed the acknowledgment a museum receives for consecrating subjects that his gallery took the risk to originate.

If the museum exhibition, which takes a minimum of a year to organize and which can fill entire floors, is a full-length novel or an encyclopedia, the gallery exhibition is an essay, composed in a relatively compressed time and space. Still, the number of shows Levy produced each season is remarkable, especially since they were so brief in duration, often only two weeks; today, gallery exhibitions run usually for at least a month, sometimes two. One museum man of Levy's generation operated with the light speed of a gallerist and the historicizing vision of a curator. As director of the Wadsworth Atheneum, Chick Austin moved on a maverick course that, in relation to Levy and Barr, stands outside the usual dealer/curator/director constructs. Austin was a magician. (In truth he was, performing as Osram the Great to benefit the Atheneum's art classes for children.) He pulled ideas, brilliantly full-blown, out of his hat almost faster than they could be contained by his trustees or absorbed by the public. Austin's museum was his theater: in 1929 he screened silent movies to foster interest in film as an art form; in 1930 he showed photography; in 1931 he premiered the

Neo-Romantics in *Five Young Painters* and Surrealism in *Newer Super-Realism*; in 1934 he held the first American retrospective of Picasso. And that was just the beginning. Austin even managed to scoop Kirstein, when, in October 1933, he brought George Balanchine from Paris, eventually to found the School of American Ballet in Hartford. It lasted only a few days there before bursting like a bubble, having floated too far from the rarefied atmosphere of New York, where it would thrive under Kirstein's aegis.

During the 1930s, Levy and Austin shuttled art and exhibitions between New York and Hartford. The dealer regularly borrowed works from the Atheneum and the director made major acquisitions through the gallery—most significant, in 1933, the Serge Lifar collection of ballet sets and costume designs. (Their correspondence reveals another aspect of Levy and Austin's transactions, with Levy frequently resorting to humorous desperation, "Dear Chick: I *must* have some consideration given to our bill or I'll take an overdose of Luminol. Wasn't I emphatic enough when I spoke to you verbally?"[50]) The exchange was more than mercantile; Levy credited Austin, for instance, for adding a touch of theater to one of his exhibitions by proposing a black wall as a backdrop for the pictures.[51]

As the art world in Levy's day was much smaller than it is today—there were probably fewer than fifteen galleries in New York at any one time in the 1930s, and only three or so concentrating on contemporary art—the boundaries between dealer and curator, gallery and museum were more fluid. Several of Levy's exhibitions toured to (or from) public institutions: *Eight*

Figure 16. **Arthur Everett Austin, Jr., as Hamlet** 1941. Collection Jean Farley Levy.

Modes of Painting, curated by Agnes Rindge, appeared at Levy's gallery on a tour organized by the College Art Association; *Abstract Sculpture by Alberto Giacometti* traveled to the Arts Club of Chicago; *Constructions in Space: Gabo* went from the Wadsworth to Levy to the Vassar College Art Gallery; and *Documents of Cubism* appeared at the Wadsworth Atheneum and the Smith College Museum of Art.

HOLLYWOOD

In the late summer of 1941, Levy took his gallery on the road, with what he called in his autobiography "a traveling gallery, a caravan of modern art."[52] He headed west, and set up shop first in San Francisco at the Courvoisier Galleries, the official dealer for Walt Disney's animation art. Levy had already presented Disney's cels in New York, in a series of very successful shows. In San Francisco, he presented a dealer's version of Duchamp's traveling *boîte-en-valise*: highlights from his New York stable,

including group shows of Neo-Romantics and Surrealists. The next stop was Hollywood, where he established himself on Sunset Boulevard and opened with Dalí. The show was tantalizingly framed by the gallery announcement: "These paintings are to be shipped to New York for exhibition at the Museum of Modern Art and will be available in Hollywood for one week only." To Soby, on the receiving end of the Dalís, Levy wrote that so far "Hollywood is exciting and the Gallery is alive and selling."[53] He also confided his financial motivation in leaving New York: to save on rent and sell off some of the old gallery stock.

Figure 17. **James Thurber,** *Julien Levy and Allen Porter en route to Hollywood* **("with Tallulah Bankhead for ballast")**
1935. Collection Jean Farley Levy.

Banking on glamour to attract publicity and customers, Levy next organized a Hollywood show of work by the Art Deco modernist Tamara de Lempicka, Baroness Kuffner.[54] Eugene Berman, who was in Santa Barbara preparing an exhibition of his work for the city's Museum of Art, reported acidly to Soby: "We're having a heat wave and temperature is near 90°. Julien opened his gallery a few weeks ago with a terrible exhibition of Lempicka and big opening party and terrific crowds. Now it's the Neo-Romantic show, much less flashy and not so swank, but it's a good exhibition and on the whole Julien is doing much better than expected, since Hollywood is such a difficult place for business."[55]

Levy was not the only New Yorker attracted to the local industry and industrialists of celluloid dreams. Out West, he met many colleagues from back East. Imagining that Hollywood might naturally respond with enthusiasm to his experience with photography and fashion, Man Ray spent the war years in Los Angeles in exile from Paris.[56] The Dada collectors Walter and Louise Arensberg had been living in Los Angeles since 1921, attracting Duchamp for visits in 1936, 1949, and 1950, as well as a steady stream of curators and museum directors hoping to land a bequest of the couple's collection.[57] (René d'Harnoncourt won, for the Philadelphia Museum of Art.) In 1941 and 1943, Chick Austin was in Hollywood to found Gates Theatre Studio with Edgar Bergen, Charles Coburn, Walter Huston, and others. Salvador Dalí went there to stage the dream sequence for Alfred Hitchcock's 1945 movie *Spellbound,* and again in 1946 at the invitation of Walt Disney to collaborate on *Destino,* an unrealized animated film based on a Mexican ballad. In 1945, MGM tapped twelve artists for a competition, won by Max Ernst, to paint a Temptation of Saint Anthony as a prop for the movie *Bel-Ami.* Despite these flirtations between art and film, artists and actors, dealers and directors, when William Copley went west in 1947 and exhibited the work of Cornell, Ernst, and Man Ray, he could not sell a thing.[58] His gallery closed the following year.

In 1938, *Vogue* profiled seven Fifty-seventh Street galleries, each with "a personality as sharp and distinct as any movie star."[59] The lineup reveals Levy's colleagues and competition at the peak of his gallery's success, beginning with Durand-Ruel, the gallery "that sold the French Impressionists to the Americans." The walls were "covered in dull brown velvet," which the writer found "curiously soothing," as were "the same Negro attendants who have been opening the doors" for great collectors for years. Alternatively, there

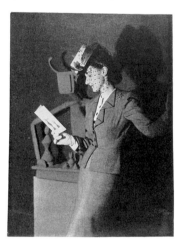

was Wildenstein, behind a Louis XVI façade, "brought, stone by stone, from France," where "a gallant Frenchman escorts clients the length of the marble hall into a beautiful Louis-Quinze room...furnished to what would have been Marie Antoinette's taste." At Marie Harriman's, the surroundings went ignored, because of the "best-looking art dealer...best skier and best bowler on Fifty-Seventh Street"; but the fare was strictly School of Paris. Levy's specialties were "Surrealism, 'the photography of the mind,' and Neo-Romanticism, 'the camera of the soul.'" His gallery was "principally for the sophisticated and the young," in marked contrast to the neighboring (and no doubt intimidating) bastions of conservative art commerce.

Not on *Vogue*'s shortlist was the Pierre Matisse Gallery, which opened just before Levy's, in late October 1931, with an exhibition of Georges Braque, Jean Lurçat, and Georges Rouault. Having served his apprenticeship at the prestigious Valentine-Dudensing gallery of modern European art, and as son of Henri (whose Museum of Modern Art retrospective opened one month after his son's gallery), Pierre had impeccable credentials. And while Levy had to "adopt" his patrimony, claiming Stieglitz and Duchamp to be his godfathers

Figure 18. **"Mrs. Alford scores in a perpetual check of black and white Forstmann wool."** Photograph taken in front of a Max Ernst sculpture at the 1944 *Imagery of Chess* exhibition, for *Town & Country*, February 1945.

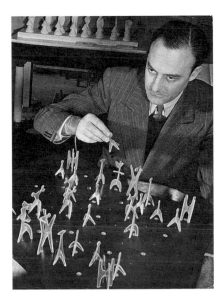

("I didn't bring them into the church. I just, in my mind, said, 'I want their blessings,' and I consider them my inspiration"[60]), Matisse was a blue-blood, who would establish the first blue-chip gallery of modern art in New York. The two dealers operated within different, at times overlapping, echelons. Matisse showed only established figures; Levy took his chances. Many artists who had a start in New York at Levy's gallery, including Calder, Giacometti, Matta, Tanguy, and Gorky, went on to enjoy sustained careers and become the new old masters with Pierre Matisse.

"IDEA SHOWS" AND DUCHAMP

Compared with Matisse's gallery, with its museumlike program, and from today's perspective, Levy's seems more an alternative space than a typical commercial gallery. In the early 1930s, he established diversity with forays into film and photography and with innovative group shows. Later in the decade, he relied on an increasingly conceptual program and featured a number of what he called "idea shows," some curated by artists. In 1938, Levy organized *Old and New "Trompe l'Oeil,"* mixing F. G. da Bibiena and William Harnett with Berman and Dalí. One of his favorite writers, Henry James, inspired *The "Picturesque" Tradition in American Painting of the Nineteenth Century,* a 1943 show of landscape paintings. The same year, *Through the Big End of the Opera Glass* focused on miniature works by Cornell, Duchamp, and Tanguy. For the 1944 *Imagery of Chess* exhibition, Levy commissioned boards and pieces from artists, several of whom also participated in a competition at the gallery. This was

Figure 19. **Attributed to George Platt Lynes, Julien Levy playing with chess set by Isamu Noguchi**

at the 1944 *Imagery of Chess* exhibition. Collection Jean Farley Levy.

something of an early Happening, with the reigning "World Champion of Blindfold Chess," George Koltanowski, scheduled to play in simultaneous matches against (unblindfolded) Barr, Ernst, Levy, Dorothea Tanning, the architect Frederick Kiesler, and Dr. Gregory Zilboorg. (The champion beat everyone but Kiesler, who managed a draw.) And in 1945, *Objects of My Affection* featured works by Man Ray selected by Man Ray.

Looming large behind these projects was Marcel Duchamp: from the trompe-l'oeil of his Rotoreliefs, to the museum-in-a-suitcase of miniature reproductions of his own art (the *boîte-en-valise*), to his binary intrigue with the conceptual play behind a game of chess and a work of art. In addition, Duchamp advocated specific artists to Levy, such as the painter Gar Sparks and the sculptor Maria Martins, who was also the model for the supine female figure in Duchamp's last work, the tableau *Étant Donnés*.[61] Levy had known and admired Duchamp (he blatantly called it hero worship[62]) since 1926, when Levy persuaded his father to buy a sculpture by Constantin Brancusi, whose interests Duchamp was representing in America. Like Stieglitz, Duchamp impressed Levy as dealer, artist, and impresario. And just as Stieglitz had influenced the first years of the Levy Gallery, so would Duchamp inspire its second phase.

Duchamp had been an active member of the Dada movement in New York throughout the teens and twenties; during the forties he functioned as a spiritual presence, detached yet omnipresent. The city was full of his European colleagues, among them artists and intellectuals who had fled the German occupation: Berman, Breton, Ernst, André Masson, Amédée Ozenfant, Kurt Seligmann, Tanguy, Tchelitchew, Ossip Zadkine. Breton, who never learned to speak English, presided over the Surrealists in exile, with the Eurocentric Levy Gallery serving as his base of operations. (The scholar Anna Balakian recalled that when, as a graduate student, she wanted to meet Breton, Levy provided the introduction at his gallery.[63]) Duchamp, a Surrealist sympathizer, contributed to Breton's projects—he designed the catalogue and

created an extraordinary installation from one mile of string for Breton's 1942 *First Papers of Surrealism* exhibition, for instance—without ever being the initiator.[64] Even in the midst of Levy's most Duchampian exploits, the artist's involvement was indirect. When the matches were on during the *Imagery of Chess* exhibition, Duchamp declined to play, preferring to act as referee.[65]

In his unpublished memoirs, Soby paid a retrospective visit to the Julien Levy Gallery, where he found Levy engrossed in yet another game of chess with Duchamp, the implication being that this was the dealer's most cherished diversion.[66] A perceptive assessment, for it does seem that, more than the satisfaction of running a business, what Levy enjoyed about being an art dealer was his interaction with the players, the challenge of coming up with successful strategies for exhibitions, the pleasure in handling the pieces themselves—particularly if they were artworks by Man Ray, Ernst, Atget, Tanning, Gorky, or Dalí.

ABSTRACTION AND ARCHITECTURE

That the Pierre Matisse Gallery survived the 1940s and the Levy Gallery did not is more than just a tribute to Matisse's greater business acumen. It also reflects changes that Matisse's powerful gallery effortlessly weathered but that would compromise Julien's "Arte Shoppe." Levy's identity was inextricably linked with Surrealism as a contemporary art movement, and by the 1940s its hold on current imagination was beginning to wane. Its passage and substitution occurred essentially in one place, Peggy Guggenheim's Art of This Century. The New York heiress's museum and gallery opened in October 1942 with a landmark exhibition of Surrealist art, made iconic in the photographs taken of it by Berenice Abbott. Important works by Ernst, Duchamp, Giacometti, and Paul Delvaux were installed by Frederick Kiesler in a custom-designed interior. Paintings were hung projected on the ends of baseball bats, against radically concave wooden walls. Biomorphic furniture—Kiesler's specially designed "seven-way units"—served as everything from sculpture

Figure 20. **Arshile Gorky,** *Eye-Spring* 1945. Ink on paper, 9 x 12 inches. Collection Jean Farley Levy.

pedestals to seating for viewers. What is not apparent from photographs of the exhibition are the kinetics: spotlights on timers flashed on several pictures simultaneously, while the rest were plunged into a darkness periodically pierced by the amplified sound effects of a train screaming through a tunnel. At the time, Levy was out of commission; he had enlisted in the army, and his gallery's interests were being carried on at Durlacher Brothers by the dealer Kirk Askew, whose passions were the Baroque and Neo-Romanticism. (Upon Levy's return to business, in March 1943, many of his artists, including one of his biggest sellers, Tchelitchew, would defect to Durlacher.) Guggenheim was the new Surrealist on the block, and her electrifying fun house blasted away most recollections of Levy's elegantly curved white walls.[67]

Art of This Century produced the next wave of change, in 1943, with a *Spring Salon for Young Artists,* selected by Barr, Duchamp, Mondrian, Soby, and others. This included work by a young painter who was visibly wrestling with what appeared now to be the European old guard of Surrealism. In November, at the behest of her advisor Howard Putzel, Guggenheim gave Jackson Pollock his first one-artist show. The brochure essay by James Johnson Sweeney charged American painters to follow Pollock's lead and "risk spoiling the canvas to say something in their own way."[68] Clement Greenberg's review saw in this artist an end to Picasso, Miró, and even Mexican mural painting as overpowering influences: American art had finally achieved a new, native influence.[69]

Of course things are never that simple. The first artist of the New York School, Pollock arrived at his innovations not, as Greenberg suggested, through esoteric study of "that American chiaroscuro that dominated Melville, Hawthorne, Poe...Blakelock and Ryder," but through avid appreciation of Surrealist automatism in the works of Matta, Ernst, and Gorky, those exiles from abroad who established themselves in New York through the Julien Levy Gallery. Levy opened at his final location in March 1943 with an exhibition of drawings by Matta (the Chilean artist's second show at the gallery) and gave

Gorky his first New York show there in March 1945. André Breton's brochure essay for the latter, entitled "Eye-Spring" (after a complex metaphor of time that turns a watch spring into a "wire of maximum ductility" located inside an "opaque case"), echoed Sweeney's claims for Pollock. In Gorky, too, there was "an art entirely new...the proof that only absolute purity of means... can empower a leap beyond the ordinary and known to indicate...a real feeling of liberty." Yet while Pollock's abstraction was being touted locally in terms of an emerging American cultural nationalism, Gorky's was being advanced as a last victory organized by the general himself, Breton, who, allied with Levy, was determined to defend the dwindling ranks of Surrealism.

In March 1947, *Town & Country* published a veiled portrait of the Julien Levy Gallery, written by a gallery assistant, Eleanor Perényi.[70] She plays "Frances" to Levy's "Mr. Jellicoe," a man who "generated a constant tension. With his pale, ascetic good looks, he made Frances think of a perpetually fallen angel." Illustrated with a cartoon by Saul Steinberg, Perényi's essay describes a day at the gallery during its declining years:

> Just now, they were in the doldrums....The opening had been successful. Mr. Jellicoe's friends, who went to all the openings anyway, liked and understood the kind of dreams and magic he was so unsuccessful in selling to the general public. But in the next day or so, the atmosphere had slowly flattened. Boiled down, the sales amounted to one or two drawings, kept in a portfolio in the office, and an almost-sold small painting in the exhibition itself.

LEGACIES AND MONUMENTS

Peggy Guggenheim closed her gallery in May 1947, having given Pollock four solo exhibitions. Levy, who had given Gorky five solos, closed in 1949 (not quite a year after the artist's suicide). Curiously, despite so many brilliant shows involving so many famous and infamous artists (to say nothing of writers, curators, dancers, filmmakers, and just plain personalities), Levy's

achievements have been subsumed by Peggy Guggenheim's Art of This Century. Perhaps this is due to her quick, succinct transformation of her program, in just five seasons, from Surrealism into Abstract Expressionism. Levy, his former openness to possibilities notwithstanding, was adamantly a Surrealist to the end.

Both Levy and Guggenheim were passionate collectors, but the scope of their acquisitions was distinctly different. Working with a string of advisors over the years (most notably, the English art historian Sir Herbert Read), Guggenheim amassed a world-class collection of modern art, primarily from the postwar period. In 1949 she opened the doors of her Venetian villa as a public museum. Levy's vision for his legacy took form in the late 1970s with a proposed Center of Surrealist Studies of Alternative Thinking and Expanding Experience, whose nerve centers would be the Levy collection and library. He proposed the package as an endowment to the State University of New York, Purchase, where he was teaching a seminar, "Surrealism Is...." The Center called for an ambitious and imaginative interdisciplinary program, involving art (for a "Surrealist Contemplation Room," students would curate a "constantly changing exhibition of two separate surrealist paintings, one classic and one recent"); literature ("in connection with the French department the Center will undertake the translations of key surrealist works [to be] serialized in the Quarterly"); cultural studies (one planned symposium was on "The Image of Woman in Surrealist Art"); psychoanalytic studies (readings in Freud and Lacan); theater (staging *Les Mamelles de Tirésias, Ubu Roi,* and other plays); film and video (Buñuel, Cornell, and Hans Richter, as well as Robert Altman, Judy Chicago, and William Wegman). The program's agenda set out to prove that, far from being dead, Surrealism had never lost its vitality. The course "Surrealist Behavior" would study "the development of certain actions as art," from Arthur Cravan to Joseph Beuys.[71]

The architecture and language of Levy's proposal can be seen as elaborations of an earlier project undertaken with Ian Woodner Silverman for a

Surrealist House, an installation for the 1939 New York World's Fair. The 1970s
Center proposal opens: "Step right up and get inside your mind, and meet
yourself crossing the frontal LOBE.... Seeing is disbelieving. Conceive before
you think." The carnival barker likewise beckoned to the 1939 World's Fair
pavilion: a "'Funny House' from a new angle," featuring "whispers," a "pneu-
matic wall," "Hallucination," and "Rocking Floors." Upon reaching the top of
an "Audible Staircase," visitors would experience the "Sensation of Falling."[72]
This idea in particular ("the public will be catapulted"), with its specter of
imminent lawsuits, may have discouraged Fair sponsors from adopting the plan.
In any case, the house was replaced by Dalí's *Dream of Venus* pavilion, with

Levy in close collaboration as the
artist's dealer and representative
in New York.[73]

 The Surrealist Center
had no such apotheosis after the
project was scrapped, for a murky
complex of reasons.[74] Levy's art
went to his Connecticut home,
and upon his death, in 1981, the bulk of the collection was dispersed at auction,
leaving no marker or monument. There is one important exception. During
the 1970s, Levy's sleeping beauty of a photograph collection was acquired
through purchase and gift by the Art Institute of Chicago. Amid the famous—
Atget, Imogen Cunningham, Walker Evans, André Kertész, László Moholy-Nagy,
Paul Strand—were the then virtually unknown Ilse Bing, Jacques-André
Boiffard, Francis Bruguière, Lee Miller, Roger Parry, Emmanuel Sougez, Luke
Swank, Maurice Tabard. (There was not a single print by Stieglitz.) For the
curator, David Travis, researching the collection for the Institute's 1976 exhi-
bition was rewarding detective work that disclosed an alternative history
of photography conditioned on the intervention of Surrealism and film.[75]

Figure 21. **Ilse Bing, *Paris, Champ de Mars Seen from the Eiffel Tower*** 1931. Gelatin silver print, 8 x 11 inches.

The Art Institute of Chicago, Julien Levy Collection; Gift of Jean and Julien Levy.

With its original vision intact, Chicago's Julien Levy Collection remains the dealer's greatest legacy.

GENTLE FADEOUT

Balancing fashionable fare with less known works, offsetting shows that sold poorly with sure hits, Julien Levy kept his gallery in business for almost twenty years. During the Depression and then during wartime, with neither collectors nor cash in abundance throughout, it was necessary constantly to invent and reinvent a market. In this respect, Levy's mercurial program, and his forays into decorative arts, commercial and portrait photography, and the entertainment industry, were resourceful efforts to keep his shop open. These activities also had the advantage of being newsworthy to the popular press. In addition to receiving constant notice in *The Art Digest, The Art News,* and *The New York Times,* the gallery received regular coverage in *Vogue, Harper's Bazaar, Life, Newsweek,* and *Time.* The December 1946 exhibit of cartoonist Milton Caniff's original drawings for *Terry and the Pirates* fetched full-page illustrated features in *Life* and *Newsweek,* both boasting of Terry's tony affiliations with "the swank New York gallery of Julien Levy."[76] There one was as likely to spot a Gorky as a Kahlo, a Cornell as a cartoon, a ballet dancer as a blindfolded chess champion, all participating in a transformative history of the gallery by "one of New York's most fashionable art shops."[77]

NOTES

1. "The two New York galleries that both Chick Austin and I frequented most were those of Julien Levy and of Durlacher Brothers" (James Thrall Soby Papers, The Museum of Modern Art Archives, addenda VI, unpublished manuscript, chap. 9, p. 22).

2. Quoted in Robert Pincus-Witten, *Leo Castelli: Gentle Snapshots* (Zurich: Edition Bruno Bischofberger, 1982), p. 20.

3. Julien Levy Gallery press release for *Review Exhibition,* October 1937, The Museum of Modern Art Library, Artist and Gallery Files, "Julien Levy Gallery."

4. Sallie Faxon Saunders, "Middle Men of Art," *Vogue,* March 15, 1938, p. 102.

5. Levy Gallery press release for *Review Exhibition.*

6. Quoted in Laura de Coppet and Alan Jones, *The Art Dealers* (New York: Clarkson N. Potter, 1984), p. 23.

7. Paul Cummings, interview with Julien Levy, May 30, 1975 (transcribed by Deborah M. Gill), Archives of American Art, p. 14.

8. Quoted in Gerald Reitlinger, *The Economics of Taste,* vol. 2 (New York: Hacker, 1982), p. v. *"À la Pagode, Gersaint, marchant jouaillier sur le pont Notre Dame, vend toute sorte de clainquaillerie nouvelle et du goût, bijoux, glaces, tableaux de cabinet, pagodes, vernis et porcelaines du Japon, coquillages et autre morceaux d'histoire naturelle, cailloux, agathes, et generalement toutes marchandises curieuses et etrangères, à Paris, 1740."*

9. Allusions to the *marché aux puces* and to curiosity shops are relevant for Levy also because of his strong personal connection with Mina Loy. Her Paris apartment was decorated with treasures from the city's flea markets; the lampshades she made and sold at her shop often incorporated found objects. (See Carolyn Burke's essay in this catalogue.) The lampshades may have inspired the trompe-l'oeil objects Levy hoped to produce. As he described them in an interview, these were photo objects with images of light bulbs and chandeliers reproduced on the shades. See Charles Desmarais, "Julien Levy: Surrealist Author, Dealer and Collector," *Afterimage,* January 1977, p. 5.

10. Soby Papers, unpublished manuscript, chap. 9, p. 22.

11. "Art and the Slump," *The Art News,* August 19, 1931, p. 19.

12. All quotations from letters written by Julien Levy to Mina Loy are from unpublished correspondence, and are reprinted here with the kind permission of The Julien Levy Estate.

13. "As for whatever contracts I make with the artists—Next time I will send you copies of a full legal contract to be used,—for the moment my terms are flexible, but usually that I pay all ordinary expenses of exhib. catalogue, insurance, shipping ... and in return ask my choice of a picture. To approximate my expenditure on extra framing when necessary, and douane [customs] and extra shipping (not in your regular shipment) I ask either cash or an extra picture" (Julien Levy to Mina Loy, September 9, [1935]).

14. Julien Levy to Mina Loy, May 9, 1930.

15. Julien Levy to Mina Loy, May 30, 1930.

16. Julien Levy to Mina Loy, July 31, 1930.

17. Desmarais, "Julien Levy," p. 6.

18. Julien Levy to Mina Loy, August 11, 1930.

19. On March 16, [1931], Levy informed Loy, "Two of your poems have been placed in Pagany (I sent you a sample copy. It was not a good number but it included my Atget's [sic])." See Pagany: A Native Quarterly, vol. 2, no. 1 (Winter 1931), n.p.; four reproductions of Atget photographs are credited to the Weyhe Gallery.

20. Julien Levy to Mina Loy, July 31, 1930.

21. Julien Levy to Mina Loy, September 22, 1930.

22. Julien Levy to Mina Loy, July 31, 1930.

23. See Maria Morris Hambourg, unpublished interview with Berenice Abbott, April 19, 1978, The Museum of Modern Art, Department of Photography.

24. Julien Levy to Mina Loy, May 30, 1930.

25. Julien Levy to Mina Loy, July 31, 1930.

26. Julien Levy to Mina Loy, n.d.

27. Julien Levy to Mina Loy, n.d.

28. Julien Levy to Alfred Stieglitz, September 11, 1931, Beinecke Rare Book and Manuscript Library, Yale University.

29. Julien Levy to Mina Loy, March 16, [1931]; Julien Levy to Mina Loy, April 3, [c. 1931].

30. Unlike other acolytes, Levy remembered getting a word in edgewise with Stieglitz. "I used to always go and stay hours and hours in his gallery and talk to him in the evenings with a sandwich and a cup of coffee" (Cummings, p. 11). Levy said he became "quite intimate" with Stieglitz, as, indeed, seems to have been the case. In December 1930 he wrote Mina Loy: "Had dinner with Stieglitz a few evenings ago. He was not the usual bore that he has been these last few years, but was very soft and inspired, quite nice and fascinating. He talked a great deal about you.... He also told us about his 'love diary.'" Unpublished correspondence in the Julien Levy Estate from Stieglitz to Levy suggests a mentoring relationship between older dealer and younger. In 1933, Stieglitz told Levy he wanted to discuss the business at An American Place, which he was having difficulties keeping open. And in 1936 he thanked Levy for sending him a copy of his book Surrealism, and congratulated him on a job well done.

31. Cummings, p. 9.

32. Allen Porter to Agnes Rindge, n.d., Agnes Rindge Claflin Papers, Special Collection, Vassar College Libraries.

33. Pierre Matisse Gallery Archive, Julien Levy Gallery file, handwritten invoice, January 1943.

34. Levy ultimately did not handle the sale of Dausse's library, which was purchased by Walter P. Chrysler, Jr., chairman of the Museum of Modern Art's Library Committee. In 1936, Chrysler gave Dausse's and Paul Éluard's libraries to the Museum, thus establishing one of the most significant museum collections of Surrealist books and ephemera in America. See Philip Boyer, Jr., "Rare Surrealist Data a Gift to

Museum Here," *New York Herald Tribune,* November 29, 1936.

35. In a 1935 letter to Mina Loy, however, Levy complained that after two shows at the gallery, Campigli was not the financial success he had hoped for.

36. This, the first exhibition of photographs by Nadar (Gaspard Félix Tournachon) in America, included only some original prints. It consisted primarily of reprints by the photographer's son Paul, who carried on his father's studio in Paris.

37. "Stieglitz and Atget created the 'honest' photograph; Hill and Nadar the 'psychological' portrait" ("Pioneers of the Camera," *The Art Digest,* December 15, 1931), p. 18.

38. Although practically every reviewer quoted André Breton, whose definition of *surréalisme* was translated in the exhibition brochure, only a few observed the emerging talent of Joseph Cornell, whose work made its public debut with the exhibition, most conspicuously on the front of the brochure. This untitled collage image has since become an icon of the movement: Levy used it on the jacket of his 1936 book and it appears on the frontispiece of Dickran Tashjian's *A Boatload of Madmen: Surrealism and the American Avant-Garde* (1995).

39. "Freudian Psychology Appears in the First American Surrealist Show," *The Art Digest,* January 15, 1932, p. 32.

40. Edward Alden Jewell, "A Bewildering Exhibition," *The New York Times,* January 13, 1932, p. 27.

41. Levy's claim that he organized the first Surrealism show in America must be qualified by the fact that Chick Austin presented an earlier show with much of the same material, *Newer Super-Realism,* at the Wadsworth Atheneum from November 15 through December 5, 1931. See Deborah Zlotsky, "Pleasant Madness in Hartford: The First Surrealist Exhibition in America," *Arts Magazine,* vol. 60 (February 1986), pp. 55–61; this excellent article compares the two shows and their receptions.

42. Zlotsky, "Pleasant Madness," p. 59. In light of Austin's observation, it is interesting to note that when Levy presented his exhibition, *Surréalisme,* he put "scandal sheets" in direct competition with paintings by including front pages from the New York *Evening Graphic* and *Daily Mirror.* These featured collage illustrations of the 1926–1927 scandal involving underage "Peaches" and her millionaire "Daddy" Browning.

43. Julien Levy Gallery brochure for *Paintings by Gracie Allen,* September 1938: "As we all know, Gracie Allen has been making pictures for years, but these are her first on canvas. When she turns her undoubtedly surrealist mind to painting the results are indescribable, but Gracie describes them as 'surrealistic.'" And Allen herself discussed her work: "There's no use hiding one's extraordinary talent under a bushel basket, even though George [Burns, of course] says that's where we should hide the pictures."

44. Film Society brochure, Program Three, March 19, 1933.

45. Julien Levy to Mina Loy, n.d.; Julien Levy to Mina Loy, March 27, 1933.

46. A. Conger Goodyear, *The Museum of Modern Art: The First Ten Years* (New York:

A. Conger Goodyear, 1943), p. 39. Goodyear described another mural: "Al Capone entrenched behind money bags, operating a machine gun, with President Hoover, J. P. Morgan, John D. Rockefeller and Henry Ford as his companions."

47. Levy and Newhall covered similar ground. In Paris, Newhall visited the studio of Paul Nadar, through whom Levy had acquired material for his Nadar exhibition six years previously. Newhall, too, appealed to Stieglitz to bless his exhibition with loans and interest in the project. As he had done with Levy's first show, Stieglitz declined the honor, offering to lend only photogravure reproductions of his classic images taken from *Camera Work*. See Beaumont Newhall, *Focus: Memoirs of a Life in Photography* (Boston: Bulfinch, 1993), pp. 44–55.

48. Levy claimed that "Alfred Barr used to complain—in fact he was quite bitter…'Julien Levy's always doing what I want to do, and he's doing it two or three years before me. It's not that I didn't want to do it at the same time Julien did, but it takes me three years to get the museum machinery running, and it takes Julien three months'" (Desmarais, "Julien Levy," p. 20).

49. Clipping from *New York Herald Tribune* on the controversial "fur-lined cup movement," January 2, 1937, and Alfred H. Barr, Jr., to Museum president, January 13, 1937, The Museum of Modern Art Archives, scrapbook.

50. Julien Levy to Chick Austin, n.d., A. Everett Austin, Jr., Papers, The Wadsworth Atheneum Archives.

51. "Dear Chick: The Gallery is now running double blast. The painting is finished and your black wall looks superb. Am eternally grateful for the suggestion" (Julien Levy to Chick Austin, n.d., A. Everett Austin, Jr., Papers).

52. Julien Levy, *Memoir of an Art Gallery* (New York: G. P. Putnam's Sons, 1977), p. 255.

53. Julien Levy to James Thrall Soby, October 27, [1941], Getty Research Institute, Resource Collections, box 3, folder 16, no. 910128.

54. Her husband, the Baron Kuffner, seems to have financed Levy's California caravan expedition. See Levy, *Memoir*, p. 87.

55. Eugene Berman to James Thrall Soby, November 7, [1941], Getty Research Institute, Resource Collections, box 8, folder 2, no. 910138.11. In an earlier, undated letter (in the same folder), Berman noted that San Francisco "didn't prove a great success, materially speaking and the Levy Gallery and we all need it very badly."

56. See Robert Berman and Tom Patchett, *Man Ray: Paris–LA* (Santa Monica, CA: Smart Art, 1996).

57. I thank Naomi Sawelson-Gorse for sharing her incomparable knowledge of this period in California. See her essay "Hollywood Conversations: Duchamp and the Arensbergs," in Bonnie Clearwater, ed., *West Coast Duchamp* (Miami: Grassfield, 1991).

58. Copley gives an excellent and entertaining account of his Hollywood gallery's short but memorable history, which includes encounters with a monkey and Stravinsky, in *CPLY: Reflections on a*

Past Life (Houston: Institute for the Arts, Rice University, 1979).

59. Saunders, "Middle Man," pp. 102, 154, 155.

60. Cummings, p. 11.

61. "Julien Levy has added two new painters to his gallery: Howard Warshaw and Gar Sparks. The latter was discovered by Marcel Duchamp" ("Gallery Notes," *View*, vol. 6, nos. 2–3 [March–April 1946], p. 28).

62. Levy described his attitude toward Stieglitz and Duchamp: "These people, as I met them, I hero worshipped" (Cummings, p. 11).

63. Anna Balakian, discussion with the author.

64. Duchamp's cover for the 1942 exhibition bears an interesting correlation to Levy's photo objects of the 1930s. The front cover of the catalogue is an extreme close-up of a stone wall, the back a close-up of a piece of Swiss cheese. Levy's trompe-l'oeil projects included fabric printed with an image of Swiss cheese (a pun, he wrote Mina Loy in an undated letter, on "dotted-swiss cheesecloth"), and with images of rocks (for pillowcases; the rocks would make the soft pillows look hard). See Cummings, p. 17.

65. In the 1950s, Duchamp would assume a more active role in the art world, this time as advisor, consultant, and independent curator for Sidney Janis, who opened his New York gallery in September 1948. Duchamp organized the major international exhibition of Dada held at Janis's gallery in 1953. See Calvin Tomkins, *Duchamp: A Biography* (New York: Henry Holt, 1996), pp. 377–379.

66. Soby Papers, unpublished manuscript, chap. 9, p. 23.

67. In response to an article about the eccentricities of space at the Guggenheim Museum, a writer a few years ago reminded *The New York Times* of Levy's achievement: "He designed his gallery with curved walls, showing single paintings on each curve. In that way, each piece of art was seen alone, to be studied at any angle, with no other painting pulling one's eye away from it" (Casey I. Herrick, "Letters," *The New York Times*, December 4, 1994).

68. James Johnson Sweeney, *Jackson Pollock*, exhib. cat. (New York: Art of This Century, 1943).

69. Clement Greenberg, "Art Review," *The Nation*, November 1943.

70. Eleanor Perényi, "Art's Sake," *Town & Country*, vol. 101, no. 4294 (March 1947), pp. 126, 198, 200.

71. All quotations from drafts for the prospectus are reprinted with the kind permission of The Julien Levy Estate.

72. The Audible Staircase was to feature a steep spiral "with microphones hidden in the wall and connected with a loudspeaker in the main hall where the public can hear reproduced the unconscious remarks, heavy breathing and laughter of those who are climbing the dark winding stair." The loudspeaker was to be labeled "What will you say on your wedding night?" The pavilion seems to have been modeled after the carnival-style installations of the London International Surrealist Exhibition of 1936. Indeed, the London show seems to have inspired also Peggy Guggenheim's 1942 exhibition.

73. Levy was only one of many spon-
sors behind Dalí's *Dream of Venus* pavilion.
As reported in *The New Yorker,* it was "pro-
moted and financed by a group of substantial
men," including "William Morris, the theat-
rical agent; Julien Levy; Edward James,
an art collector and a Dalí fan; I. D. Wolf
of the Pennsylvania State Exhibit at the
Fair; W. M. Gardner of the Gardner Display
Company; Ian Woodner, an architect; and
Philip Wittenberg, a lawyer." The article
went on to mention Gracie Allen, whom
Morris's agency represented: "Last fall it
seemed a good idea to Miss Allen...to have
an exhibit in New York of the paintings she
had executed in her spare time from the
microphone, and the show was held at the
galleries of Julien Levy, who is a sensi-
tive man with a flair for the unexpected."
See Margaret Case Harriman, "A Dream
Walking," *The New Yorker,* July 1, 1939,
pp. 22–27.

74. In 1977 it was reported that
ground had been broken for the $12 million
visual arts instructional facility, which
would house, among other things, a Surrealist
Center (Luisa Kreisberg, "Surrealism at
SUNY," *The New York Times,* April 24, 1977).
There are no records accessible of what later
transpired, but it seems that Levy withdrew
the project when works in his collection,
which were being stored temporarily at
the University Art Museum, were damaged
by a flood.

75. Travis, assistant curator of photog-
raphy at the time of the gift, recently
recounted in an informal discussion with
the author that his most valuable tool in

researching the Levy Collection was the
Paris telephone book. Many of the photog-
raphers were only experimenting with the
medium, and had not gone on as profes-
sional artists. The critical importance of
Levy's vision of photography is ostensibly
the subject of Rosalind Krauss and Jane
Livingston's *L'Amour Fou: Photography and
Surrealism* (New York: Abbeville, 1985), the
catalogue of an exhibition organized by
the Corcoran Gallery of Art, Washington,
D.C., to which the Art Institute of Chicago
lent many works from the Levy Collection.

76. "Terry and the Pirates Invade New
York Gallery," *Life,* January 6, 1951, p. 35.

77. "Terry and the Pirates Storm Art
Gallery in New Adventure," *Newsweek,*
December 16, 1940, p. 48.

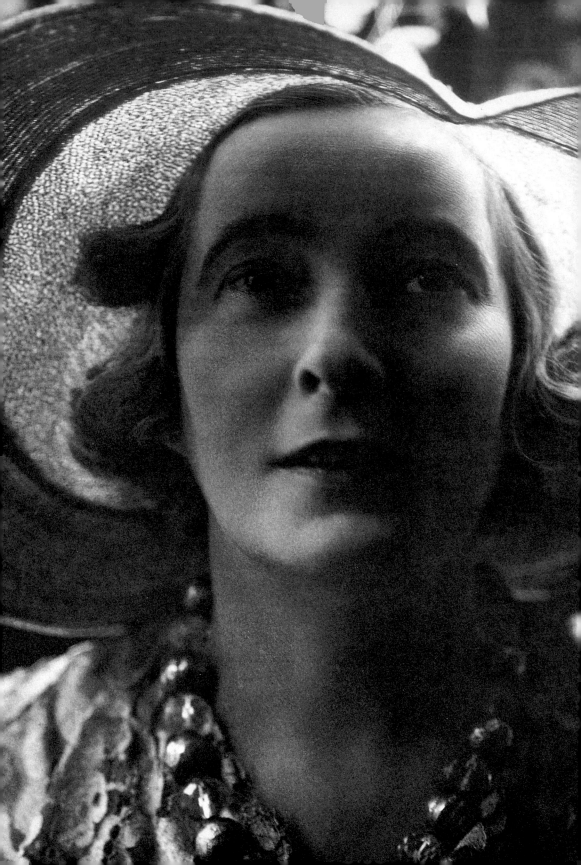

Loy-alism: Julien Levy's Kinship with Mina Loy

Carolyn Burke

Although Julien Levy claimed Alfred Stieglitz and Marcel Duchamp as his godfathers in art, the poet-artist Mina Loy was his secret godmother, teacher, and muse. From 1927, the year Levy met this English expatriate and married her daughter Joella, until 1981, the year of his death, Levy's curious liaison with his mother-in-law shaped his thoughts about life and art. It is no exaggeration to say that this elective affinity molded his sensibility. Loy's modernist values became those of Levy's gallery even before she began acting as his Paris representative, just as her instructions to the newlyweds guided them through their first decade of marriage. Like many triangles, this alliance was unstable. It eventually undermined Levy's marriage and Loy's relations with her daughter, as well as Loy's belief that she had found in Julien the son she had always wanted. Yet to a considerable extent, Levy's life as collector and dealer is marked by the totemic works of art that passed through his hands *because* of their deeply felt kinship—the bond he called, only partly in jest, "Loy-alism."

LE NOUVEAU-NÉ

Levy was "ripe to be deeply impressed"[1] when he met Mina and Joella soon after arriving in Paris in 1927. At twenty-one, the recent Harvard student in fine arts enjoyed special status as the son of Edgar Levy, a New York City real estate mogul who made occasional purchases of art. The young man's friendship with Duchamp dated from when the suave Frenchman learned that Levy had persuaded his father to buy Constantin Brancusi's *Bird in Space,* and it was at Duchamp's suggestion that Julien Levy accompanied him to France in February 1927. An aspiring writer, Levy knew Loy's free-verse tribute to the sculptor, "Brancusi's Golden Bird," which had been published

Figure 22. **George Platt Lynes, *Portrait of Mina Loy*** 1930. Gelatin silver print, 9⅝ x 7¾ inches. Collection Jean Farley Levy.

in *The Dial* in 1922 and reprinted in the catalogue for Brancusi's 1926 exhibition at the Brummer Gallery—where Levy and Duchamp first met.

On the trip across the Atlantic, Levy drank in the older man's tales of the New York Dadaists, the Arensberg salon, and the elusive Mina Loy. Their fellow passenger Robert McAlmon, the publisher of Loy's provocative book of poems *Lunar Baedecker,*[2] concurred in Duchamp's admiration for the beautiful, talented, and tragic Mina—still mourning the love of her life, the poet-boxer Arthur Cravan, after his disappearance nearly ten years earlier in Mexico. McAlmon also stressed her position in the Montparnasse "crowd"—which included Ezra Pound, Ernest Hemingway, Gertrude Stein, James Joyce, Brancusi, Man Ray, Jane Heap, and Margaret Anderson. By the time they arrived in Le Havre, Levy was imagining Paris as "a whole universe of people and talk I had scarcely suspected in reading their books," and Mina's daughter Joella as the girl of his dreams.

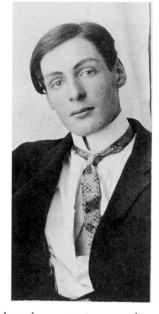

In Levy's account of his first day in Montparnasse, McAlmon steered him to the Hôtel Istria on the rue Campagne-Première, then to a party at Peggy Guggenheim's studio.[3] Within a short time Levy found himself talking to Mina—whose bon mots impressed him as the equal of Duchamp's. With Guggenheim's backing, he learned, Mina had recently opened a shop and gallery, where the celestial imagery of *Lunar Baedecker* materialized in her luminescent lampshade designs. But it was the sight of Joella—"the most wonderful *jeune fille* in the world," according to McAlmon—that Levy recalled as "light breaking through [the] clouds" of cosmopolitan chitchat. From then on, this glamorous mother-daughter duo were linked to his sense that "at gatherings such as this the most fertile

Figure 23. **Mina Loy's second husband, Arthur Cravan:** poet-boxer, Dada icon, and alleged nephew of Oscar Wilde, n.d.

Collection Joella Levy Bayer.

contacts between the best talents of New York and Paris could be made."

If McAlmon's introduction provided Levy with his entrée to expatriate Paris, Loy's sponsorship completed his education. "Apology of Genius," her poetic defense of the creators of modernism as society's "lepers of the moon," spoke for his generation as well as her own. Mina shared his belief that poets and artists were natural aristocrats. She preferred dinners at

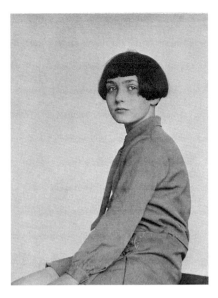

Brancusi's studio—lamb grilled peasant-style on a brazier—to formal repasts, and she told amusing stories about Levy's new neighbors—Man Ray and Kiki, Berenice Abbott, and their eccentric "discovery" Eugène Atget. What was more, Man Ray had often photographed Mina, Joella, and her younger sister, Fabienne; members of the "crowd" were known to debate who was the most striking of these "three raving beauties."[4] Mina's friendships with Gertrude Stein and Alice Toklas, Natalie Barney, Sylvia Beach, and Adrienne Monnier soon opened their salons to her young American friend.

Levy saw Loy as an artistic and social mentor, but he was drawn to her also emotionally. His mother, another "elusive, beautiful woman," who had encouraged his artistic pursuits, died when he was seventeen; he had dealt with the loss, he wrote, by "put[ting] my inarticulate filial feelings into a neat little package and hid[ing] it in a back drawer." These feelings surfaced in Paris. While he found Joella enchanting, Levy's description of Mina betrays the erotic charge he felt in her presence: at forty-four, she looked "exceptionally young, almost blond, because her grey bobbed hair held so much vivacity." Moreover, Mina's life had a legendary quality. Julien was mesmerized by stories

Figure 24. **Berenice Abbott, *Jemima Fabienne Cravan Lloyd*** 1928. Gelatin silver print, 10 x 7 ½ inches.

Collection Jean Farley Levy.

of her Victorian upbringing, her marriage to Stephen Haweis, an English Post-Impressionist, their life in prewar Paris and Florence (where Joella was born), and her role in New York Dada high jinks, but even more so by the tales of her second husband, Cravan—whose daughter Fabienne looked to him like "some small mythological beast." He had fallen in love with the family legend.[5]

Levy's temperament blinded him to Loy's more worldly side. Previous candidates for Joella's hand had presented themselves, but none was deemed suitable. While Mina was reluctant to part with her assistant—Joella actually ran the business, calming her volatile mother and charming the customers—she gave her consent more rapidly than Julien's memoir suggests. Mina believed that Julien, the firstborn son, would inherit a fortune, and that it was the role of the wealthy to support the "geniuses." (This practice was followed, albeit sporadically, in expatriate Paris. McAlmon's wealth came from a settlement by his father-in-law; Loy's shop depended on the backing of Peggy Guggenheim, who was proving a forgetful patron.) The Levy–Loy alliance solved some problems but created others, including that of mixed marriage. The Levys were Jewish, as was Mina's father, but she had grown up in the Church of England and then turned to Christian Science, a more "modern" religion, which Joella also practiced. That Julien loved his prospective mother-in-law as well as his fiancée made things easier or more complicated, depending on one's perspective.

Once Edgar Levy was reconciled to the match (and after an investigation by private detectives), the couple became engaged. Whatever uncertainty Joella may have felt went into its own back drawer. She was in love for the first time. She admired her fiancé's precocious savoir faire, his knowledge of art and literature, his elegance and ambition. Having been brought up as a *jeune fille* who was allowed to read neither *Lunar Baedecker* nor *Ulysses,* Joella had made a life for herself as her mother's right hand. Her social graces had been polished at expatriate gatherings; her orderly approach to day-to-day

work had made the shop a success. It would not occur to her until later that her devotion to Mina had prepared her for a similar role with Julien, whose success in his gallery owed a great deal to her social ease, artistic taste, and managerial talents. Whatever hesitation Joella may have felt at the time, she was swept up in the purchase of a trousseau and plans for an Italian honeymoon—both paid for by Julien's father, who also booked the couple a suite on the *Île de France*.

Levy's memoir hints that the choice of witnesses at the civil wedding ceremony mattered more to him than did the differences in background. Brancusi and Joyce were both invited to give their blessings, but the sculptor came alone, bearing an oval bronze entitled *Le Nouveau-Né* (*The Newborn*). If Joyce had missed the chance to be Levy's literary godfather, Brancusi's presence, not to mention his anticipatory gift, ratified Levy's new life—his rebirth as a modern whose relations by marriage would nourish the "fertile contacts between the best talents of New York and Paris."

THE PERSISTENCE OF MEMORY

The "children," as Mina called them, considered her their cherished confidante during their first decade of marriage. Julien wrote frequently and at length, despite, or because of, his obligation to spend the next two years in his father's business. The decorative scheme of the young couple's Manhattan apartment was modified until it met with her approval, their relations with Julien's family were analyzed with ironic touches, and the progress of their

Figure 25. **Constantin Brancusi, *The Newborn* (*Le Nouveau Né*)** (Version I, 1920, close to the marble of 1915). Bronze, 5¾ x 8¼ x 5¾ inches.

The Museum of Modern Art, New York; Acquired through the Lillie P. Bliss Bequest. The artist's wedding gift to Julien and Joella Levy.

erotic life spelled out in anglicized French ("The love marches to perfection," *"L'amour marche à merveille"*[6]). In response to Joella's quandary about their social life, Mina wrote, "In America, where society is divided, you must choose the best Jews in preference to the second best Christians," and added, "I am sure Edgar knows the best Jews—because he's one of the best himself."[7] But Julien, locked in rivalry with his father, joked that he would give his name to the as yet unknown Freudian complex "by which one is irritated by one's father and loves one's mother-in-law."[8]

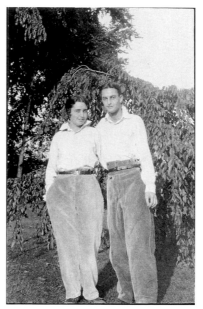

For the next decade Julien remained under Mina's spell. Their surnames expressed their spiritual kinship, he believed. Lowy, Mina's name at birth,[9] was a variant of his own; in Jewish tradition they belonged to the same noble tribe. Yet in his view, Mina, Joella, Fabi, and he formed a "race" of their own. At times it seemed that Mina was his "real family": temperamentally he was more her child than was Joella.[10] He embraced Christian Science, and as if this proof of devotion were not enough, he also adopted Mina's Cravan cult— shaving his head in the summer as the poet-boxer had done, and imagining himself his "related-in-law." During Julien's business apprenticeship, his complicity with Mina was at its height. While he offered himself, emotionally, as a Cravan substitute, calling Mina and Fabi his "outlaw-inlaws,"[11] his predisposition toward Surrealism was enhanced by André Breton's claiming Cravan as the movement's precursor. Mina was flattered by her son-in-law's infatuation. For the rest of her life, she would enjoy Julien's stimulating correspondence, sharp, sensitive readings of her manuscripts, and juicy gossip about the New York and Paris art worlds.

Figure 26. **Joella and Julien** 1927. Collection Joella Levy Bayer.

In the meantime, Mina's paranoia about her business required Julien's attention. Running the shop without Joella was too much for someone of her nature, she wrote. Her designs were being copied, workmen stole her production secrets, her accountant cheated her. Moreover, she longed to finish her "novel"—a thinly veiled autobiography leading up to her life with Cravan— but could not see how to disentangle herself. After months of negotiations, Edgar Levy sent her $10,000, a sum that allowed her to buy out Peggy Guggenheim, sell the shop, and concentrate on her writing—while binding Julien to his apprenticeship. He and Joella had to depend on Edgar, but Mina could be free. While Julien acted as her parent, protector, and liberator, she became, in a sense, his alter ego.

As of 1931, Mina would also be Julien's agent. He had come into his inheritance and was free to do as he pleased. With Joella's encouragement and Mina's shop as precedent, he decided to open his own gallery, the "art shop"[12] where he would perpetuate the modernist version of aristocratic values he had absorbed in the company of his wife and mother-in-law. In turn, he asked Mina to be his Paris representative. Although Julien originally may have wanted her to play this role to justify the monthly checks he had begun sending, he soon gained from the arrangement. As Cravan's widow, Mina had considerable cachet among the Surrealists, and the Left Bank apartment she had recently bought with Edgar Levy's money would be a convenient headquarters for Julien's yearly buying trips.

Indeed, it was Mina's aesthetic—as expressed in her rue St.-Romain apartment—that nourished Julien's artistic spirit. A poetic mélange of flea market finds, decorative schemes devised to hide flaws, and idiosyncratic art gallery composed of Mina's paintings, Fabi's drawings, and photographs of Cravan, it also featured Mina's collection of antique bottles, Fabi's bird cages as room dividers, and silver paper in floral patterns pasted over cracks in the plaster. "Mina's household, always in a state of delicate equilibrium between threadbare poetic freedom and aristocratic elegance," Julien wrote, became

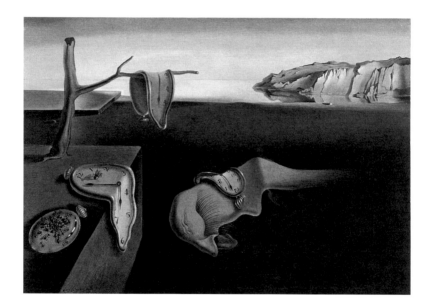

Figure 27. **Salvador Dalí, *The Persistence of Memory* (*Persistence de la Mémoire*)** 1931. Oil on canvas, 9½ x 13 inches.

The Museum of Modern Art, New York; Given anonymously.

the site of his "balancing act between America and Europe," and its decor, "by Loy out of the *marché aux puces*," a source of inspiration in that it seemed to have "no practical, moral, or prestige implications whatsoever." Mina made a virtue of necessity by juxtaposing the flea market finds and trompe-l'oeil (Loy?) solutions to the problems of rented lodgings, but to Julien, "this abundance of subtle, casual visual experience was a banquet" for which he had been starved.

During the early years of Julien's gallery he increasingly saw Mina as muse, in addition to her roles of mentor, sweetheart, and alter ego. In 1932, with Joella's support, he began a creative project of his own, a number of short films of artists in their native environments. This series was to include Brancusi, Fernand Léger, Max Ernst, and Mina, who observed that "her true environment should be a dustbin." Julien's portrait of his mother-in-law sauntering past the stalls at the *marché aux puces* expresses his quasi-Surrealist sense of creativity as a series of encounters with no "implications" other than the expression of poetic temperament. While it connects her flea market aesthetic to a democratizing impulse—dethroning "high art" by recycling humble materials available to all—it disregards the impulse behind her inventive creations.[13] On better days, Mina's eclecticism, humor, and imagination enabled her to make enchanting assemblages of these fragile *objets trouvés,* but at other times she made it clear that she hated being "poor"—to which Julien objected that her "poverty [was] really luxury."

Ironically (for a dealer), Levy's disdain for the social necessities of artistic production influenced his understanding of Surrealism. At first it seemed largely a matter of *épater la bourgeoisie* by shaking off the weight of artistic convention. In 1931 he purchased Salvador Dalí's *The Persistence of Memory,* another work associated with Loy in part because he stored it in her apartment, where it kept company with her fantastic decor.[14] When the work appeared in the Julien Levy Gallery's *Surréalisme* exhibition, it stole the show and pushed Levy's growing reputation into the realm of public sensation. The Spaniard was

important, Levy maintained, because his painting offered "imaginative snapshots of intercranial space...displacement of the orgasm, mobilization of the dream, intercourse of the eyes, the smashing of the mental molecule." Mina was more concerned with Dalí's motivation: Was it black magic, drugs, or as he insisted, delirium? Both she and her son-in-law saw Surrealism in terms of its personalities. To Mina the Surrealists dabbled in the black arts, while to Julien they provided excitement, unpredictability, and a perverse gaiety—a shift in perspective leading away from the material world, toward the "more real than real world behind the real."[15]

EXPECTATION

Few Americans appreciated Surrealism's foundations in European intellectual tradition. In this respect Levy was an exception. Although Breton would tell him that he could never be a true Surrealist, he had a Surrealist sensibility nonetheless, and he understood the movement's cultural bases even if he interpreted them less politically than Breton might have wanted. In the mid-1930s, while working on the manuscript of his book *Surrealism,* Levy came to see his subject not just as the latest wave of vanguard protest but also as the "revolution in consciousness" appropriate to the historical moment. In New York, removed from the *entre deux guerres* atmosphere of its origins, it was understood, however, as a school of art meant to shock, as in the case of Dalí, or to release the viewer into the land of dreams, as in the case of another Levy Gallery artist, the American Joseph Cornell, whose "objects" Julien began showing in 1932.

By then he was also planning an exhibition for Mina. She had set aside her novel and was painting a series of visual meditations on the theme of "incipient form." Telling herself that if she were to "go back, begin a universe all over again,"[16] she might capture primordial shapes in the act of becoming, she painted angelic profiles, human faces emerging from snail shells, and other "sunset-creatures" on a blue-gray base of mixed sand, gesso, and plaster she

called "fresco vero." This cerulean blue, dubbed "bleuaille" by Julien, unified the exhibition but failed to please the reviewers. "Those who respond to Blake and Arthur Rimbaud and other such mystics may also come to terms with Mina Loy," the New York *Evening Sun* observed. "No others need apply."[17] Mina's paintings nevertheless made an impression on those who took a spiritual view of Surrealism (Cornell, for instance, whose interest in Mina dated from her 1933 show). Moreover, that only one painting sold did not shake Julien's faith in her genius.[18]

Soon he was thinking of a second show for her. In 1934, after the success of Florine Stettheimer's designs for Gertrude Stein and Virgil Thomson's *Four Saints in Three Acts,* everyone wanted "pictures which are 'féerique' and candy box and magical," as Julien described. He told Mina that she should "avoid too much 'bleuaille' so as to strike the eye more keenly,"[19] and teased her about her double role as his Paris representative and one of the artists she was to encourage. "Consult Loy," he wrote when discussing the gallery's schedule; "I am counting on Loy," he reminded her.[20] Their correspondence moves from richly detailed accounts of shipments, payments, and problems of storage to his and Joella's New York social life and growing family: by 1936 the couple had three sons. (They were, in the language of his letters, a chosen people, "the Levites.") Despite Mina's increasingly absentminded approach to her own affairs, she performed surprisingly well as his agent, negotiating with gallery regulars—Eugene and Leonid Berman, Alberto Giacometti, Pavel Tchelitchew, Giorgio de Chirico, and Massimo Campigli—handling advances, and working with Julien's Paris counterparts, Pierre Colle and Léonce Rosenberg. But what Julien wanted was another Dalí.

Chief among his candidates was Richard Oelze, a German recluse living in Paris whom Alfred Barr and Julien both met in 1936.[21] Oelze's disturbing paintings struck Julien as a kind of "installment diary" in which "a landscape of last week is this week populated with trespassers." In the following week's canvas, "innumerable comments may be distinguished in the foliage and in the

Figure 28. **Richard Oelze, _Expectation (Erwartung)_** 1935–1936. Oil on canvas, 32⅛ x 39⅝ inches.

The Museum of Modern Art, New York; Purchase.

clouds, and Oelze's picture will have passed beyond his control, to become, aided by his minutely introspective imagination, a new astonishment."[22] While this quality of "astonishment" augured well for his New York success, Oelze's introspective quality spoke directly to Mina's similarly brooding imagination.

In her role as gallery scout she was to draw him out, offer moral and financial support, and select those canvases that seemed suited to America. The story of the friendship that ensued between the introverted Oelze and the equally reclusive Loy is retold in her novella à clef *Insel*—whose title is also her name for the artist. Oelze was, she thought, a "congenital surrealist."[23] He admired her blue paintings and thought her "an extraordinarily gifted woman"; of course, someone in his position would be inclined to praise the work of his new patron's representative. What she saw in his canvases is revealing. Their biomorphic shapes, "at once embryonic and precocious," had taken the idea of incipient form several steps in the direction that she had tried to follow.

Insel makes clear that Mina responded as much to the peculiar atmosphere surrounding this "uncommon derelict" as she did to his paintings. Like Julien, he was a younger man in whom the roles of masculine double and substitute lover-son combined, but this time, *she* was the dominant figure, with the power to subsidize his artistic production. Soon Oelze was dining regularly in her rue St.-Romain apartment, then living there during her absence. She looked upon him as a potential Loy-alist and soul mate, like Julien: gazing at her portrait of Cravan, Oelze's fictional counterpart declares, "We would have been as one." This communion breaks down, however, when the Mina figure fails to respond to hints about his dire circumstances. In reality Oelze needed Mina's, and Julien's, help to obtain a visa to the United States, where he hoped to escape, as would other Surrealists: a left-winger, he was persona non grata in France. Strangely, though, *Insel*'s narrator turns to images of skyscrapers as depicted by a Surrealist after mentioning his "ardent yearning to flee to New York from a threatening war."

In October 1936, while Oelze made his way to neutral Switzerland, his paintings traveled to New York as part of a shipment to Julien.[24] Before its departure, Oelze's *Expectation* had hung in Mina's apartment, where it communed with the portrait of Cravan.[25] "Whenever I'm in the room with it," Mina wrote, "I catch myself looking at that sky—waiting for something to 'appear.'"[26] Decades later it is impossible not to see in the work the years of its composition, 1935–1936, and in the mute backs of its Magritte-like subjects bourgeois refugees already on their way to the death camps. Julien had been prescient in 1936 when writing about the ominous hints contained in Oelze's landscapes.

PORTRAITS OF THE ARTISTS

Mina gave Oelze a talismanic gift shortly before he "dematerialized" from her life: an object made by Cornell and brought to her by Julien as an act of double homage. In Cornell's small black box one saw "the delicious head of a girl in slumber afloat with a night light flame on the surface of water in a tumbler." Its images had been "cut from early *Ladies Journals* (technically in pupilage to Max Ernst)," but it was, she wrote, "in loveliness, unique in Surrealism." Mina decided that the box "belonged" to Oelze after he looked at her imploringly, no doubt for other reasons, and with this conscience-salving present she linked the two young Surrealists Oelze and Cornell in a chain of connections forged by her relations with Julien.[27]

Cornell, Levy wrote in 1936, was "one of the very few Americans at the present time who fully and creatively understands [*sic*] the surrealist viewpoint."[28] Since the day in 1931 when Cornell first walked into the gallery, his trust in Julien had grown, in part because of their shared practice of Christian Science. Cornell admired the Surrealists' techniques but feared their "deviltry"—taboo in his religion. Julien encouraged Cornell's wish to perform an innocent countermagic by giving him the antique French boxes he had bought while sleuthing at the *marché aux puces* with Mina. With this creative

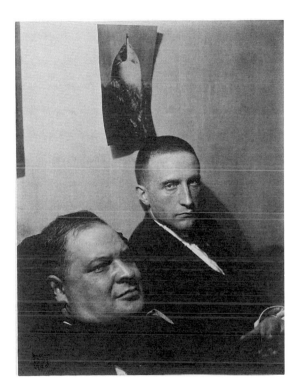

Figure 29. **Man Ray, *Duchamp, Joseph Stella*** 1920. Gelatin silver print, 8 x 6¾ inches. Thomas Walther Collection.

gesture, he linked her flea market aesthetic to Cornell's box-making and a home-grown American Surrealism—one that would recycle images of European culture while freeing them from their social and political grounding.

Cornell's next imaginary meeting with Mina took place in 1933, when he saw her paintings at Levy's gallery. Their celestial blue backgrounds made such "indelible impressions," he wrote, that they stayed with him for a decade, until he and Mina became friends upon her return to New York.[29] Cornell constructed two boxes in homage to the Loy-alists as kindred spirits and sources of inspiration—for himself and for one another. In *Portrait of Mina Loy,* a Man Ray photograph of her in a top hat is embedded in shards of glass; a handwritten inscription on the back quotes the phrase "imperious jewelry of the universe" from Mina's "Apology of Genius"—which Cornell must have known from her 1933 exhibition catalogue (like Julien he misattributed the phrase to another of her poems, "Lunar Baedecker"). In the mid-1930s, when this box and the other were made, Cornell's knowledge of his dealer's muse relied on limited sources. It is fitting that his portrait of Julien uses the same format. As a companion to Mina's, it acknowledges their kinship and their place in his network of associations.

By the 1940s, Cornell was one of the Levy Gallery's regular artists, but he still worried about the morality of art. On his visits to her New York apartment for tea and his favorite sweet, marzipan, he and Mina, inveterate salvagers of others' discards, discussed the morality of artistic "borrowing." "You have a way of making things your own," she told him. What he did was not, as he feared, "pilfering," since the process of selection and recombination made these images his own.[30] Because he had turned to her as a fellow believer in Christian Science, she used the occasion to make a suggestion of her own. He should create "an object of magnitude: the Kingdom of Heaven."[31] With this suggestion, and Cornell's response to it in his next project, *Aviary,* Surrealist technique broke free of its earthly moorings to concern itself with the spirit.

This unexpected development is elaborated in Loy's "Phenomenon in American Art," the perceptive essay she wrote on Cornell's 1949 exhibition at the Egan Gallery (after Julien's gallery had closed six months earlier).[32] During her inspection of *Aviary,* Brancusi's bird sculptures had come, or flown, to mind: "It was a long aesthetic itinerary from Brancusi's Golden Bird to Cornell's Aviary. The first is the purest abstraction I have ever seen, the latter the purest enticement of the abstract into the objective." Cornell had lured an abstraction, the soul, into "objective" form—a goal the Surrealists could not have imagined, with their shallow conception of reality.

This long itinerary was one Mina and Julien had followed together, from his first encounter with Brancusi's bird sculptures at the Brummer Gallery in 1926 until the demise of his gallery more than three decades later. By then he and Joella had each divorced and remarried, and Mina had moved to a communal household near the Bowery, where she would make low-relief three-dimensional constructions on the theme of homelessness, and enlist the members of her household as the next generation of Loy-alists. When Levy, Duchamp, and David Mann, a young art dealer, inspected these Cornell-inspired works, Mann offered her a show and Julien wrote that he and Marcel were happy to be her agents because they were both "in love with Mina Loy." In the catalogue of her 1959 exhibition at the Bodley Gallery, Julien praised these "contrary pictures...lyric in their drabness, whole in their fragmentation," and Duchamp noted succinctly: *"Hauts-reliefs et bas-fonds, Inc., Marcel Duchamp (admiravit)."* [33] Between them they measured the changing emphases of the aesthetic that had informed the modernist alliance both in general and in emblematic form, in the relations between Mina Loy and Julien Levy.

NOTES

1. Unless otherwise indicated, all quotations are from Julien Levy, *Memoir of an Art Gallery* (New York: G. P. Putnam's Sons, 1977). See also Carolyn Burke, *Becoming Modern: The Life of Mina Loy* (New York: Farrar, Straus & Giroux, 1996; University of California Press, 1997).

2. The title of Loy's book, *Lunar Baedecker* (published in Paris by Contact in 1923) was misspelled by McAlmon. Her poems have been reprinted several times, in various editions: *Lunar Baedeker & Time-Tables* (Highlands, NC: Jonathan Williams, 1958); *The Last Lunar Baedeker,* ed. Roger L. Conover (Highlands, NC: The Jargon Society, 1982); and *The Lost Lunar Baedeker,* ed. Roger L. Conover (New York: Farrar, Straus & Giroux, 1996), the definitive edition.

3. This studio, which took on mythic significance for Levy as the site of his introduction to "the Loys," was Laurence Vail's atelier in the passage du Maine, down the alley from Loy's lampshade "factory."

4. Sylvia Beach, *Shakespeare & Company* (New York: Harcourt, Brace, 1956), p. 113.

5. Levy's decision in *Memoir* to call Mina's daughters "the Loys," despite his awareness that Joella and Fabi had different fathers and surnames (Joella's was Haweis, and Fabienne's was Lloyd, Cravan's legal name), suggests the hold Mina had on his imagination decades later.

6. Julien Levy to Mina Loy, n.d. [c. 1927].

7. Mina Loy to Joella Levy, n.d. [c. 1927]. Although Joella understood Julien's desire to distance himself from Levy family expectations, she and Edgar forged a close bond, and Edgar approved of her influence on Julien.

8. Julien Levy to Mina Loy, n.d. [c. 1928].

9. Mina removed the *w* from her birth name, Lowy, for her exhibition at the 1903 Salon d'Automne.

10. "Race," "real family": Julien Levy to Mina Loy, n.d. [c. 1928].

11. Julien Levy to Mina Loy, April 3, 1931.

12. Julien Levy to Mina Loy, January 2, 1931.

13. Mina bought materials for her lampshades—antique maps, glass globes, curio bottles—at the *marché aux puces* because of her limited means and reverse aesthetic snobbery: one had to have either the best quality or things that were amusing, she believed.

14. Dalí and Cravan were associated in Levy's mind: both struck him as "archetypal creatures"—Cravan "a praying mantis," Dalí "a black panther or, at rare moments, a rat."

15. Levy, *Surrealism* (New York: Black Sun, 1936; repr. New York: Arno, 1968, and Da Capo, 1995), p. 5. Joella's experience stood her in good stead when it fell to her to obtain Dalí's cooperation for subsequent exhibitions at the gallery—where she often saw to practical matters such as soothing temperamental artists and hanging their shows.

16. Mina Loy, *Insel* (Santa Rosa, CA: Black Sparrow, 1991), p. 37. See also Burke, *Becoming Modern,* p. 377.

17. "Attractions in the Galleries," New York *Evening Sun,* February 4, 1933, sec. 7, p. 10. The exhibition ran from January 28 to February 18, 1933.

18. Failing to receive the introductory essay by Ezra Pound or Gertrude Stein that he had requested from Mina, Julien reprinted her "Apology of Genius" in the exhibition catalogue.

19. Julien Levy to Mina Loy, n.d. [c. 1934].

20. Julien Levy to Mina Loy, April 2, 1934, and February [c. 1935].

21. See Alfred H. Barr, Jr., "Oelze, 1936, and His Expectation," in Edouard Jaguer, *Richard Oelze* (New York: Lafayette Parke Gallery, 1991), n.p.

22. Levy, *Surrealism,* p. 28.

23. Quotations in the next two paragraphs are from Loy, *Insel.*

24. Oelze returned to Germany in 1938. He served in the war and was taken prisoner, and was released by the Americans in 1945. See Jaguer, *Richard Oelze.*

25. Oelze and Cravan cohabited in Levy's mind as well: a letter written around autumn 1936 commends Loy for giving Oelze her apartment, suggests she "ask him to repay you with drawings," and requests "a photo of the Oelze painting" (*Expectation*) and one of Cravan, for inclusion in Levy's book *Surrealism,* for reasons of "family snobbism." (No photograph of either Cravan or the painting was included in the published book.)

26. Mina Loy to Fabienne Lloyd, n.d. [c. autumn 1936], fragment of letter in the author's collection.

27. Loy, *Insel,* p. 168.

28. Levy, *Surrealism,* p. 28.

29. Joseph Cornell to Mina Loy, November 21, 1946.

30. Mina Loy to Joseph Cornell, n.d., Joseph Cornell Papers, Archives of American Art, roll 1058.

31. Mina Loy, "Phenomenon in American Art," Joseph Cornell Papers, Archives of American Art, roll 1965.

32. The unpublished text of Loy's essay exists in several versions, the most complete of which is the manuscript in the Cornell Papers, the source of all quotations given here.

33. "High reliefs and lower depths, Inc., Marcel Duchamp (admired) [this]."

Julien Levy: Exhibitionist and Harvard Modernist

Steven Watson

Julien Levy enjoyed a precocious talent for affiliation—he connected himself with the Right Crowd before they were widely recognized as such. Levy gravitated toward the edge of stylish discovery, and he quivered (figuratively) in the presence of modernist fashion. He demonstrated this affinity early on when he mentally appointed Marcel Duchamp and Alfred Stieglitz his twin godfathers, as "the two men who have had the greatest formative influence on my present temper." The avant-garde pedigree was also reflected in the choice of the two men—James Joyce and Constantin Brancusi—who were invited to officially witness Levy's 1927 marriage in the *mairie* of the Fourteenth Arrondissement, in Paris.[1] Even the genealogy of his wife, Joella, was significant. She was the daughter of the poet-artist Mina Loy, who was in turn the widow of the Dada icon boxer-poet Arthur Cravan. Taken together, Julien's "ancestors" were towering figures of the generation of modernism just before his own. Joella soon detected her husband's interest in belonging to that historical avant-garde family, and concluded that Julien had fallen in love with her mother as well as her. The transatlantic writer-artist mix of Levy's "relatives" demonstrated his strenuous cosmopolitanism. Each of these relations was associated with the American avant-garde efflorescence of 1913–1917.[2] In an avant-garde version of the Social Register, Levy boasted blue-blood ancestry, even if it was only appropriated and idealized.

Within his own generation, Julien Levy was an important figure in a rich network that I call the Harvard modernists. They included Lincoln Kirstein, Arthur Everett ("Chick") Austin, Jr., Alfred Barr, Jr., Kirk Askew, Philip Johnson, Henry-Russell Hitchcock, John McAndrew, Agnes Rindge, and secondarily, John Becker, Jere Abbott, Arthur McComb, and Edward Warburg.

Figure 30. **Freshman-year portraits** of (*top left and right*) Kirk Askew and Henry-Russell Hitchcock and

(*bottom left and right*) Julien Levy and Philip Johnson. Courtesy Harvard University Archives.

During the early years of the
Depression, this constellation utterly
changed the landscape of modernist cul-
ture in New York and thus in America.
They were informally known as "the
family," or sometimes "the friends" or
"the little friends," and Levy defined
socializing with them as "family parties."
Whatever the term, its various forms
suggest that Levy's friends were con-
scious of the collective effort, which was

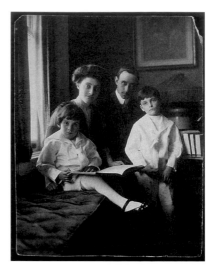

both collegial and social. Writing to Gertrude Stein shortly before she died in
1946, Virgil Thomson described the aspirations of the group:

> It all comes out clear now what you meant last summer by "pioneer-
> ing" which is just what we all, that is the little friends, have always
> been doing and maybe it isn't so easy for all of them though certainly
> it wasn't always so easy for us but any way it is the only thing any
> American can admit doing and respect himself because a pioneer is
> the only thing we can imagine ourselves being noble as or understand.[3]

The Harvard modernists were rooted in the Fine Arts Department of
the university. The key faculty members (their respective acolytes named in
parentheses) were Paul Sachs (Alfred Barr, Kirk Askew), Edward Forbes (Chick
Austin), Kingsley Porter (Agnes Rindge, Henry-Russell Hitchcock), and
Chandler Post (Julien Levy).

The godfather of the Harvard family was Paul Sachs. He was short,
volatile, businesslike, and prescient. After fifteen years with his family's Wall
Street firm, Goldman, Sachs, he moved to Cambridge and purchased Shady
Hill, the ancestral home of high culture in the United States.[4] The white
Federal-style mansion was known in the nineteenth century as "the Cambridge
Parnassus," and in the twentieth it became the training ground for the nation's

Figure 31. **Julien Levy (right) with his family** c. 1910. Collection Jean Farley Levy.

first generation of museum professionals. To Levy, Sachs was "the kingmaker," and he is widely credited as the man who shaped America's museum profession, through his course "Museum Work and Museum Problems," which was instituted in 1921.

Julien Levy came to Sachs through the intervention of his mother—an ideal entry into the Harvard circle. Mrs. Levy believed ardently in her son's creativity and supported it. (The money she left Julien when she died, for example, financed the opening of his gallery in 1931.) Julien was buoyed by her faith in his writing talent, but his literary ambition was set back when he received a D in freshman English; he recalled that his cavalier treatment of commas and his habit of inventing verbs "got pretty sour treatment."[5] After Julien's mother consulted Paul Sachs—providentially, his wife had been a Radcliffe classmate of hers—he summoned Julien to his office. Julien's major would make no difference to his ultimate career, Sachs advised, and fine arts promised smaller classes. Levy was the product of a progressive education, and he valued independent study. Soon he was making regular trips to Shady Hill, where he was one of the handful of undergraduates admitted to the museum course. Levy could barely tolerate Sachs's administrative how-tos, and the prospect of negotiating with trustees exceeded his limited patience. "I judged myself as somebody incorrigibly rebellious against the kind of tact and politesse it takes," he concluded. "Somehow or other I have to be my own boss."[6]

Although Levy found the Fine Arts Department through Sachs, it was Chandler Post who led him in the direction of his greatest interest. Post sometimes took groups of students to the movies, shepherding them in whistling at Gloria Swanson on screen. It was unusual for an art history professor to express his passion for popular culture so openly (these movie-going adventures took place before Gilbert Seldes's idea of the "seven lively arts" had entered the popular imagination). Spurred by his love of movies, Levy initiated a course of independent study that compared the psychology

of chiaroscuro and straight photography. Working in the darkroom, he saw the magic of an image blooming at his fingertips, and photography became his first love.

During his Harvard years, Levy made instrumental connections to the Harvard modernists that would later help establish him in the art world. He was tutored by Henry-Russell Hitchcock around 1926; he submitted pieces to Lincoln Kirstein's *Hound and Horn* (they were rejected); he studied with Chick Austin in the "Egg and Plaster" course (so called because it taught fine-arts techniques with the messy primary ingredients of painting and sculpture); and for a Fogg Museum exhibition of modern art in student collections he lent Alfred Barr several works on paper by Klee, Chagall, Schiele, and Campendonk. At Harvard he met Kirk Askew and Agnes Rindge and John McAndrew (who would be one of the Levy Gallery's first secretaries).

Julien Levy never graduated from Harvard, dropping out during his senior year. He bounced from a job as an errand boy on a Gloria Swanson movie to plans for making his own films in Man Ray's studio. He hadn't the least of a plan. Levy was not the only one in the Harvard group who remained uncommitted to a professional identity. Until the age of twenty-four, for example, Philip Johnson jumped from music to mathematics to philosophy, before finding his mission in promoting International Style architecture. Lincoln Kirstein's aspirations switched from painter to novelist to poet to horseman to diplomat to dancer to dance impresario. As he later said, "I was unformed, had no ideas, no instant philosophy, and I was very, very lucky."[7] His remark echoes Levy's self-evaluation: "I didn't have discipline, but I found my way somehow into the most extraordinary, lucky coincidences.[8]

Through his involvement with the Harvard modernists, Julien contributed to a collective accomplishment that proved critical in the dissemination of modernist culture in America. Even parceling out that group accomplishment into individual achievements, one comes up with an extraordinary list. They created institutions: the Museum of Modern Art, the School of American Ballet,

the Wadsworth Atheneum. They embraced new disciplines in the museum: film, architecture, industrial design. They introduced to the United States Surrealism, International Style architecture, and Neo-Romanticism. Taken together, they functioned as a monopoly on modernist culture in New York.

In some cases, their campaigns on behalf of modernism had counterparts in Europe, for the Harvard modernists were transatlantic cosmopolitans, associated with London, Berlin, and Paris.[9] The United States was the first country to train museum professionals, and the first to establish a museum to modernism. Perhaps most remarkable about the Harvard modernists was the speed with which they fought their war for modernism, the key campaigns waged between 1929 and 1934. Virgil Thomson developed a theory about the enormous professional freedom enjoyed by his Harvard friends:

> You must remember the Depression scared the hell out of the powerful rich. The shakeup of the rich in 1929 destroyed their confidence in their ability to run the art and literature world. We could do all sorts of things in places they thought they were running. They let their curators take over for a minute. For five to ten years the intellectuals were allowed to run things.[10]

The spirit of the Harvard crowd cannot be defined narrowly. Philip Johnson described it as "a concatenation of Harvard and homosexuals and modernism as a creed. And we were all believers in world improvement and the idea the world is fixable, and we were good Enlightenment thinkers."[11] The Harvard modernists wrote no group manifesto, but several elements of their loosely shared beliefs—less than a credo, more than coincidental links— united them. Three beliefs common to the Harvard group relate to Julien Levy.

Figure 32. **George Platt Lynes,** *Agnes Rindge* c. 1934. Collection Linda Nochlin.

The Harvard modernists saw the traditional art hierarchy—which granted museum status only to painting and sculpture—as insufficient and inaccurate. They believed that galleries and museums should broaden their purview to accommodate photography, film, architecture, industrial design, and performance. Although they rarely embraced craft or folk art, the Harvard modernists radically diffused the line between low and high culture, and between disciplines.

The interdisciplinary model of synthetic study of art as artifacts of civilization derives in part from Charles Rufus Morey, the Princeton professor who taught Alfred Barr a course that synthesized all the artistic manifestations of medieval civilization. By the time Barr taught this interdisciplinary model to Lincoln Kirstein,[12] Barr had visited the Bauhaus, which exemplified in its curriculum the merging of art, craft, design, and architecture. Barr introduced this interdisciplinary approach in his pioneering course on modernism at Wellesley, and Kirstein brought the interdisciplinary model to life at the Harvard Society for Contemporary Art.[13] The Society opened in February 1929 with a show of American artists that, by placing a Donald Deskey cocktail tray next to an Arthur B. Davies painting, suggested the Society's range of tastes and its penchant for debunking the traditional hierarchy. The Society's next exhibitions shifted from modern German printing to Buckminster Fuller's Dymaxion House to American cartoonists (drawn largely from the pages of *The New Yorker* and *Vanity Fair*) to modern photography (not only "art" photographs, but also vernacular examples from the daily press, surgical photographs, and aerial shots). The Society devoted an exhibition to its model, the Bauhaus, as well.

The Harvard Society for Contemporary Art's shows preceded similar interdisciplinary exhibitions at the Museum of Modern Art. Upon being appointed director of the Museum in 1929, Barr wrote in a manifesto: "In time the Museum would probably expand beyond the narrow limits of painting and sculpture in order to include departments devoted to drawings, prints, and photography, typography, the arts of design in commerce and industry,

architecture (a collection of projects and maquettes), stage designing, furniture, and the decorative arts. Not the least important collection might be the *filmotek,* a library of films."[14] (Barr was not able to effect his multidisciplinary approach at the Museum until 1932, when architecture and photography were exhibited for the first time.)

At his gallery, Julien Levy exemplified the Harvard modernists' catholic embrace of media and the desire to topple existing hierarchies—*épater la bourgeoisie* was essential to his character. By initially focusing on photography, he placed himself at the adventurous margins of the art world. Levy quickly realized that he would not be able to support himself by the sale of photographs—collectors didn't know how to regard works that were not "unique" objects. Sales of paintings became his chief source of revenue (and it was not so much the famous as the bread-and-butter artists such as Eugene Berman and Massimo Campigli who kept the gallery afloat). While making his compromise with the gallery's commercial necessities, Levy continued to support the apparently unexhibitable and the noncommercial. He developed plans to sell nonprecious, quasi-Surrealist objects (we would call them multiples): dotted fabric to be called "Swiss cheesecloth," and soft pillowcases printed with images of hard rocks. Levy began showing experimental films in the gallery within a few months of its opening. The initial program offered Léger's *Ballet Mécanique* and Man Ray's *L'Étoile de Mer,* and Levy later showed the Buñuel and Dalí films *Un Chien Andalou* and *L'Âge d'Or,* and G.W. Pabst's *Die Dreigroschenoper.* These screenings went on to feature performance, when John McAndrew accompanied the films on piano. At the time, Levy's informal showings provided one of few avenues for experimental films in the United States. The screenings evolved into a film society, which itself complemented Alfred Barr's vision and, in 1935, became the Film Library at the Museum of Modern Art.

The Harvard modernists placed the artist (and the architect) at the center of the visual temper of an age, surrounded by the scholar, the collector, and the dealer. "The happiest periods," Kirk Askew observed, "have

been when all four worked in close collaboration."[15] In our age of blinkered fiefdoms, the Harvard modernists' collaborations across disciplines and across professions are striking. They were not strenuously aspiring to be "interdisciplinary"; knowing about art, literature, and music was part of being a modern gentleman, and Harvard provided a milieu (not in its formal curriculum, but in the circle of the modernists) that superseded strict professional divisions. Within the Harvard constellation one found museum administrators (Barr, Austin, Abbott) and curators (Barr, Austin, Kirstein, Johnson, Hitchcock), gallerists (Levy, Askew, Becker), academics (Rindge, Hitchcock, McAndrew, McComb), impresarios and propagandists (Kirstein, Austin, Johnson).

Sources of independent financial support for the Harvard modernists freed them from relying entirely on the largesse of an older, more conservative patron class. Levy was able to start his gallery because his mother's will provided him with a trust fund, but his inheritance was perhaps the smallest of the Harvard modernist fortunes. When his father's real estate business fell off in the Depression, Levy's inheritance prospects grew slimmer. The families of his Harvard friends had deeper pockets. Through Louis Kirstein's more generous support, for example, Lincoln Kirstein was able to publish *Hound and Horn* for some seven years (1927–1934) and to found the School of American Ballet (1934). Edward Warburg eagerly became a young cultural philanthropist, supporting the Museum of Modern Art, the School of American Ballet, and the opera *Four Saints in Three Acts*. Philip Johnson's father gave his undergraduate son stock in the Aluminum Corporation of America; during the

Figure 33. **Leon Bakst, costume design for Vaslav Nijinsky as the Rose from *La Spectre de la Rose*** 1911.

The Wadsworth Atheneum, Hartford; The Ella Gallup Sumner and Mary Catlin Sumner Collection Fund.

1920s boom it rose in value so rapidly that the son's fortune soon outstripped the father's, and the Cleveland native became a college-age millionaire. Johnson supported the projects of his Harvard friends, commissioned work by such modernist architects as J. J. P. Oud and Mies van der Rohe, and in 1932 set up and financed the Department of Architecture at the Museum of Modern Art, which debuted with the epochal *Modern Architecture: International Exhibition.* Two years later Johnson inaugurated a design department, which opened with his exhibition *Machine Art.*

Julien Levy's gallery was to be an essential link in the tightly run Harvard group because its operation could move swiftly and its personnel was well connected. Assessing the gallery's first three years, Joella Levy commented: "Julien's great success came from his having all the artists across the pond. Because we could hang as we wanted, print what we wanted, all at top speed."[16] Levy collaborated (fractiously) with Lincoln Kirstein in 1932 on the infamous *Murals by American Painters and Photographers,* which introduced photography to the Museum of Modern Art.[17] Levy felt less close to Alfred Barr: he suggested in his autobiography that Barr was jealous of the fact that his gallery could move faster than the Museum. Nonetheless, Levy influenced the Modern's collection; acquisitions through him included Salvador Dalí's *The Persistence of Memory,* Joseph Cornell's *Taglioni's Jewel Casket,* and Pavel Tchelitchew's *Hide and Seek.*[18] Levy was most strongly associated with Chick Austin at the Wadsworth Atheneum; Levy's loans and suggestions shaped the first Surrealist art exhibition in America, in 1931, and an early Neo-Romantic exhibition,

Figure 34. **Max Ewing, Lincoln Kirstein posing as a gondolier, from the portrait series *The Carnival of Venice*** c. 1933.

Yale Collection of American Literature, Beinecke Rare Book and Manuscript Library, Yale University.

and among the key works at the Wadsworth bought from Levy's gallery was the Serge Lifar collection of designs for Diaghilev's Ballets Russes and Dalí's *Paranoiac-Astral Image.*

The Levy Gallery's first secretary, John McAndrew, exemplifies the professional and personal ties between the gallery and the collective of Harvard modernists. At Harvard he had worked with Chick Austin in the Egg and Plaster course, and he knew Lincoln Kirstein through the Harvard Society for Contemporary Art; in 1929 he met Philip Johnson, fortuitously, on an architectural research trip in Europe; he was secretary of the Levy Gallery in 1931–1932; in the latter year, with Austin's recommendation and Agnes Rindge's academic connection, he began teaching at Vassar; five years later, through his connection to Philip Johnson and Alfred Barr, he became the director of the Department of Architecture at the Museum of Modern Art. McAndrew's career moved fluidly among commerce, academia, and the museum world without his ever leaving the circle of Harvard modernists. Julien Levy was crucial in this, and he was the one who perhaps best understood the practicalities of art commerce. Virgil Thomson, describing a "family council" about *Four Saints in Three Acts,* noted that only Levy offered any practical help.

The Harvard modernists did not employee exclusively the avant-garde's model, which cast modernism as a break with the past, minimizing historical precedents. Regarding modernism as part of art historical progression, the Harvard group explored the links between past and present. This reflected, to an extent, the historical emphasis that dominated all academic training, not only Harvard's. Illuminating the bonds between modernism and tradition, Chick Austin pioneered the presentation of theme shows in American museums; his first, *Landscape Painting,* in 1931, suggested aesthetic continuity between past and present.

The "old" art taste of this generation was Italian Baroque painting and sculpture, from the sixteenth and seventeenth centuries. Previously undervalued, it came into vogue in the early 1930s, mainly because of the

Figure 35. **New York *Evening Graphic* and *Daily Mirror* front pages covering the "Peaches" and "Daddy" Browning scandal**

1927–1928. Collection Jean Farley Levy.

work of three members of the Harvard circle. The fruitful complement of art historian, museum director, and art dealer—Arthur McComb, Chick Austin, and Kirk Askew—led the revival. McComb organized the first museum exhibition on the Baroque in the United States, at the Fogg in 1929, and wrote an influential text. Chick Austin organized a larger exhibition, *Italian Painting of the Sei- and Settecento,* which opened at the Wadsworth Atheneum in January 1930. Kirk Askew pioneered the New York gallery exhibition of Baroque painting, with a show that opened in February 1932. Henry-Russell Hitchcock exemplified this embrace of the modern and the historical in his early-1930s architectural exhibitions, which concerned, among other subjects, International Style architecture, museum design through the ages, and the architecture of H. H. Richardson. Lincoln Kirstein, who would describe himself as a classicist, around 1932 began to disassociate himself from modernism and move toward support of neoclassicism and figurative art.

Of the Harvard modernists, Levy may have been the least interested in academic art history. His references depended chiefly on current sources: popular culture instead of high culture, ear-to-the-ground gossip rather than history books. Levy was always ahead of everyone, noted the painter Maurice Grosser, and was the first to buy a movie camera. Older art interested him primarily as possible precursor of Surrealism (for instance, sixteenth-century Giuseppe Arcimboldo as a model for Dalí), and he devoted one exhibition to *Old and New "Trompe l'Oeil."* But he also decorated his gallery with photostats from New York tabloids showing the "Peaches" and "Daddy" Browning scandal of 1927. He enjoyed picking up art-world party talk as a means of staying ahead. "He never wanted to leave a party," his wife Joella recalled. "He'd always say, 'I want to stay, something might happen, something amusing might happen.'"[19]

Although Julien Levy was not the most prominent of the Harvard modernists, he played a crucial role in the visionary campaign they collectively waged on behalf of modernism. He envisioned his gallery as an outgrowth

of his "ingrained exhibitionism," for, he said, he was "an exhibitionist, if only of other people's work." Levy worked in the trenches of Fifty-seventh Street, and he formed vital links with Paris, with the museum world, with academia. "All one can do is activate energetically," he wrote in 1934, "and hope, in the middle of the battle where all perspective is lost, that one tone may emerge finally with health, wealth, and happiness on the plus side of the ledger."[70]

NOTES

1. These invitations were made by Mina Loy. Joyce never showed up, and Brancusi arrived late, out of breath, bearing a small oval brass sculpture, *Le Nouveau-Né.*

2. Among the connections to the first American avant-garde: Alfred Stieglitz, the godfather of the American avant-garde, introduced both photography and modernist art (Picasso, Matisse, Picabia) to the United States. Marcel Duchamp, star of the Armory Show in 1913, helped foment New York Dada when he lived in the city from 1915 to 1918. In New York, *The Little Review*'s serialization of Joyce's *Ulysses* led to a seminal censorship trial in 1921. The Constantin Brancusi jokes at the Armory Show—they usually involved something about eggs—were second only to the Duchamp jokes. Arthur Cravan, who lived in New York in 1917 and disappeared in Mexico in 1919, became a Dada icon.

3. Virgil Thomson to Gertrude Stein, April 15, 1946, Stein Collection, Yale Collection of American Literature, Beinecke Rare Book and Manuscript Library, Yale University.

4. The house had been the home of, in succession, Charles Eliot Norton, Edward Forbes, and Walter and Louise Arensberg. Paul Sachs bought it in 1915.

5. Paul Cummings, interview with Julien Levy, May 30, 1975 (transcribed by Deborah M. Gill), Archives of American Art, p. 6.

6. Cummings.

7. Lincoln Kirstein, interview with the author, August 6, 1992, New York.

8. Cummings.

9. European capitals were crucibles for the Harvard modernists. The nine-month trip that Alfred Barr and Jere Abbott took in 1927–1928, which included visits to Moscow and Berlin, was seen by both, in retrospect, as one of Barr's defining events. Kirk Askew spent three months each summer in London. Philip Johnson made Berlin his informal headquarters in the 1930s; there he discovered modern buildings, boy bars, and fascism. Henry-Russell Hitchcock traveled through Europe looking for modern buildings. Two defining discoveries in Lincoln Kirstein's life—George Gurdjieff in 1927, and George Balanchine in 1933—occurred in and around Paris.

10. Virgil Thomson, interview with the author, April 30, 1987, New York.

11. Philip Johnson, interview with the author, October 8, 1987, New York.

12. Alfred Barr and Jere Abbott served as advisors to Kirstein in 1928–1929.

13. Kirstein was the inspiration behind the Society; John Walker III and Edward Warburg were the other two founders. About the organization, Kirstein commented: "It's my brain, Eddie's money, and Johnny Walker's social contacts" (Agnes Mongan, quoting Kirstein, interview with Robert Brown, June 19, 1979, Oral History Project, Archives of American Art).

14. Barr, "A New Art Museum," in *Defining Modern Art: Selected Writings of Alfred H. Barr,* ed. Irving Sandler and Amy Newman (New York: Harry N. Abrams, 1986), p. 69.

15. Kirk Askew, lecture on the occasion of Paul Sachs's seventieth birthday. Collection Pamela Askew.

16. Joella Levy to Mina Loy, December 5, 1934. Joella felt that they moved more speedily also because Allen Porter (officially the gallery secretary, actually something more influential), who helped install the shows, was color-blind.

17. As Levy told it, Kirstein invited him to select photographers with the promise that they would be entered in the competition for a photo mural at Rockefeller Center. Edward Steichen subsequently told Levy that Kirstein had promised him the prize, and Levy felt swindled. The *Murals* show was controversial; among its offerings was a painting by Hugo Gellert entitled *"Us Fellas Gotta Stick Together"—Al Capone,* which depicted J. P. Morgan, John D. Rockefeller, Sr., Herbert Hoover, Henry Ford, and Capone.

18. The more fertile connection between Levy's gallery and the Museum of Modern Art came through James Thrall Soby, who collected and wrote about Surrealism and Neo-Romanticism. Although Soby did not attend Harvard, he was an instrumental figure among the Harvard modernists. He was Chick Austin's right-hand man in the early 1930s and subsequently Alfred Barr's ally, and thus influential at the Museum.

19. Joella Bayer, interview with the author, August 16, 1986, Montecito, California.

20. Julien Levy to Mina Loy, n.d. [c. 1934].

Plates

Texts by Ingrid Schaffner

In 1936, Julien Levy assembled a first history of the movement he so crucially promoted. Surrealism, he wrote, "is a point of view, and as such applies to painting, literature, photography, cinema, politics, architecture, play, and behaviour." For Levy it was essentially a way of life, and he structured his book accordingly. *Surrealism* is an album of pictures, quotations, poetry, cinematic sketches, jokes, and games illustrating key Surrealist precepts and artists, such as PROVERB, METAPHOR, ERNST, DREAM, CINEMA. Its fluid framework was perfectly suited to Levy's claim that "Surrealism is not a rational, dogmatic, and consequently static theory of art."

Levy's *Surrealism* reflects its times. During the 1930s and 1940s, when modernism was becoming established in America, artists, dealers, curators, and writers seemed ready and willing to respond to the wide range of cultural styles arriving from Europe—Bauhaus, Cubism, Surrealism, Neo-Romanticism—as well as to an increasingly vital national scene. In the spirit of Levy's *Surrealism,* and to make vivid the dynamism of his day, we have borrowed from the composition of his book and assembled the picture section of our portrait according to a list of terms based on Levy's own illustrations of Surrealism. Of course, these terms are intended only as cues, prompts, not finite readings. Levy himself pointed out the "essentially anti-definitive and anti-explanatory" Surrealist point of view: "The surrealist object precedes definition, appears suddenly, alive and replete with suggestion."

Figure 36. **Lee Miller, Julien and Joella Levy installing the 1932 Max Ernst exhibition**

Collection Joella Levy Bayer.

Abstraction

The Surrealists cultivated forms of abstraction that were fixed for the possibility of aleatory intervention. Seeking chance, they developed modes of automatism such as *fumage* (drawing with smoke), *frottage* (rubbing textures from random objects), and stream-of-consciousness "automatic" writing or drawing. Often the automatic element served as a point of departure for the artist to marshal the imagery of chance toward desired representations.

Never a puritan, Levy showed a full gamut of abstractions at his gallery. Besides the Surrealist abstraction of Max Ernst, Arshile Gorky, Matta, Wolfgang Paalen, and Yves Tanguy, there was the Constructivism of Xenia Cage and Naum Gabo, the Machine Abstraction of Marcel Duchamp, I. Rice Pereira, and Theodore Roszak, the manipulated photography of Emilio Amero, David Hare, and László Moholy-Nagy. In 1938, Levy presented an exhibition of Cubism; when seen in the context of Levy's gallery, however, the works divulged Surrealist aspects. Alexander Calder's mobiles, which Levy was the first to exhibit in New York, twisted and turned in response to invisible currents of air, their movements seemingly directed by pure chance. Roszak claims to have experienced some difficulty shaking the Surrealist label that stuck to his sculptures long after he showed with Levy. This is a revealing comment on the art world at large, for it suggests how powerfully a gallery—its reputation, a dealer's vision and style—may influence the way works are perceived when exhibited. The Julien Levy Gallery made art surreal.

Plate 1. **Theodore Roszak, *Airport Structure*** 1932. Copper, aluminum, steel, brass; height: 19⅛ inches, diameter: 7 inches. The Newark Museum; Purchase 1977, The Members' Fund.

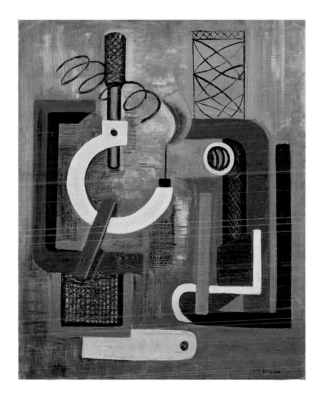

Plate 2. **I. Rice Pereira, *Curves and Angles (Composition)*** 1937. Oil on canvas, 30 x 24 inches.

Collection John Bocchieri.

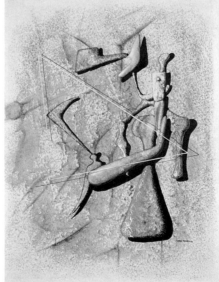

Plate 3. **Wolfgang Paalen,** *Untitled* 1938. *Fumage* (smoke painting), 16 x 12½ inches. Collection Harold and Gertrud Parker.

Plate 4. **Yves Tanguy,** *Composition* 1944. Gouache on paper, 12 x 8⅞ inches. The Menil Collection, Houston; Gift of Alexander Iolas.

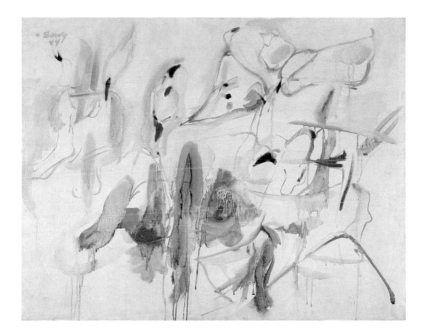

Plate 5. **Arshile Gorky,** *Love of the New Gun* 1944. Oil on canvas, 29¾ x 37¾ inches. The Menil Collection, Houston.

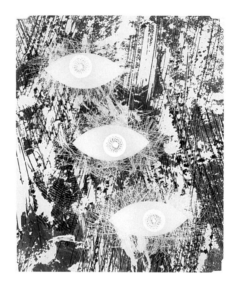

Plate 6. **Emilio Amero, *S Cloud/Eyes in Sky*** n.d. Photogram, gelatin silver print, 9⅜ x 7¾ inches. Collection Jean Farley Levy.

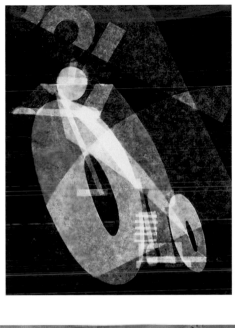

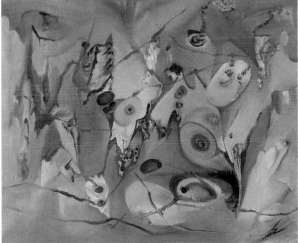

Plate 7. **Oscar Nerlinger, *Motorrad im Rennen (Racing Motorcycle)*** 1925. Photogram, gelatin silver print, 8¾ x 7 inches. Thomas Walther Collection.

Plate 8. **Wolfgang Paalen, *Quelque Part en Moi (Somewhere in Me)*** 1940. Oil on canvas, 15 x 18 inches. Collection Harold and Gertrud Parker.

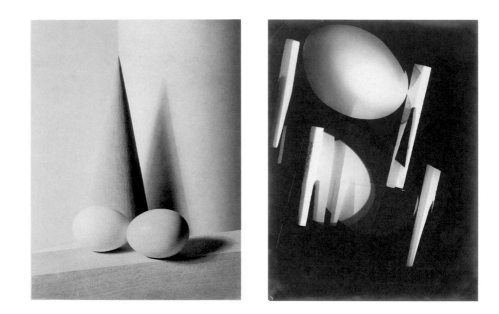

Plate 9. **Paul Everard Outerbridge, Jr.,** *Consciousness* 1931. Brown-toned silver gelatin print, 9 7/16 x 7 1/8 inches.

The Art Institute of Chicago, Julien Levy Collection; Special Photography Acquisition Fund.

Plate 10. **László Moholy-Nagy,** *Fotogramm* 1925. Unique gelatin silver print, 9 3/8 x 7 inches. Collection Camera Works.

Plate 11. **Lee Miller, *Untitled (Nude)*** c. 1933. Gelatin silver print, 6¾ x 8¹⁵⁄₁₆ inches. Thomas Walther Collection.

Plate 12. **Francis Bruguière, *Untitled*** c. 1927. Gelatin silver print, 9½ x 7½ inches. Thomas Walther Collection.

Ballet, Cartoon, and Cinema

In 1924, in his widely read book *The 7 Lively Arts,* the critic Gilbert Seldes elevated slapstick films, comics, musical comedies, slang humor, revues, popular songs, colyums, and vaudeville (along with their mass audiences) to the formerly exclusive precincts of high art. In step with the times, Julien Levy enlivened his gallery by mixing high and low, culture and entertainment, putting movies and comics alongside the ballet on his program.

In 1933, Levy presented the exhibition *Twenty-five Years of Russian Ballet from the Collection of Serge Lifar* with works by Leon Bakst, Georges Braque, Fernand Léger, and Picasso, to name a few of the celebrated artists who had designed sets and costumes for the Ballets Russes. Lifar, a principal dancer in the company, had inherited his collection from the great impresario Serge Diaghilev. The exhibition was purchased outright by Chick Austin for the Wadsworth Atheneum, an acquisition that Lincoln Kirstein deemed a masterstroke. Kirstein, who in his memoirs cites his unwitting attendance of Diaghilev's sumptuous Venetian funeral as one of the decisive moments of his life in art, copied the Russian recipe. With choreographer George Balanchine, Kirstein invited Paul Bowles, Virgil Thomson, Paul Cadmus, and other avant-garde musicians and contemporary artists to participate in a School of American Ballet. In 1937 he presented an exhibition of the newly formed company's Ballet Caravan Collaborators at the Julien Levy Gallery.

Julien Levy bears the distinction of being among the first to show the work of Walt Disney in a commercial gallery; in 1938 he exhibited animation art for the film *Snow White and the Seven Dwarfs.* Cultural interest in the cartoonist's art was percolating at the time; the Museum of Modern Art included two frames from Disney shorts in the 1936 *Fantastic Art, Dada, Surrealism* exhibition. Levy's own critical interest might be traced to an article by Leo T. Hurwitz in the May 1931 issue of *Creative Art,* a magazine to which

Levy himself contributed. Entitled "Mice and Things: Notes on Pierre Roy and Walt Disney," Hurwitz's article compared still-life imagery by Roy, an artist who was iconic of Levy's vision of Surrealism, with the "ridiculous Mickey Mouse...quite the sublimest thing that today flashes across the gaudy screen." Further cultivating

his cartoon audience, Levy showed original drawings for *Terry and the Pirates* by the comic strip artist Milton Caniff in 1940.

For the Surrealist, cinema came as close to rendering the ethereal world of dreams as visual representation could get, complete as it was with movement, montage, flashbacks, jump cuts, and foreshadowing. Levy's first gallery initially accomodated a small projection room, so that viewers could see films displayed in the same space as photographs, paintings, and sculpture. And film was all the rage during the early 1930s. According to a report in the September 1932 *Creative Arts,* everyone was doing it: "Julien Levy returned from Paris in July with some esoteric films.... Lincoln Kirstein and Henwar Rodakiewiez made a 16mm. movie of life on Cape Cod. Margaret Bourke-White and Jay Leyda also worked on a film....Walker Evans returned from the South Seas where he had been with Adolf Dick: a fascinating film resulted." Over the years, Levy showed many artists' films. He collected and sold film stills at the gallery, and he promoted a vision of photography that expressed the cinematic, through montage and movement. He even made short films of his own: portraits of Max Ernst, Mina Loy, and Lee Miller; comic and surreal scenarios, one involving a mysterious pair of black gloves, and a nude descending a staircase, and featuring an appearance by Gala Dalí and a solarized Joella Levy.

Plate 13. **Walt Disney Studio, cel from *Pinocchio*** 1938. Gouache on celluloid, 7¼ x 8½ inches. Collection Jean Farley Levy.

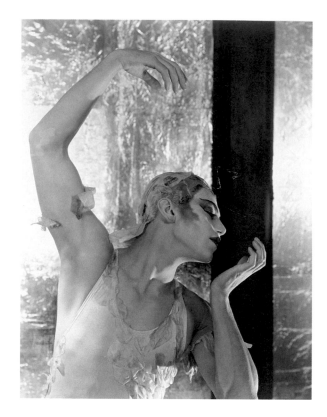

Plate 14. **George Platt Lynes,** *Serge Lifar—La Spectre de la Rose* n.d. Gelatin silver print, 7¾ x 5¾ inches.

Collection Jean Farley Levy.

Plate 15. **Joseph Cornell, *A Dressing Room for Gilles*** 1939. Box construction, 15 x 8⅝ x 5¹¹/₁₆ inches.

Richard L. Feigen, New York.

Dream

In his book *Surrealism,* Levy quoted from *The Tibetan Path of Knowledge,* Sigmund Freud, André Breton, and Salvador Dalí, in defining Surrealism as collective "attempts to discover and explore the 'more real than real world behind the real,'" or the world of dreams. According to Freud, an unconscious parent of Surrealism, dreams prove the existence of the subconscious. And the subconscious was the primary realm of Surrealist operations, through which Dalí, for one, announced his hope for deliverance from the "principle of reality, thus finding a source of splendid and delirious images."

Levy discerned two phases of Surrealism, each by way of the dream. In the first, "passive" phase, members merely recorded their dreams as a form of automatic writing. In the second, "active" phase, which brought the Surrealists to "their revolutionary social doctrines" and "the necessity of changing the world," dreams became templates for reality, through which might appear "a painting by Dalí, a cinema, the surrealist object." The more the world filled with such manifestations, as seen and sold at the Julien Levy Gallery, the closer reality came to achieving an ideal state of surreality.

Plate 16. **Victor Brauner, *Démons du Parapluie (Demons of the Umbrella)*** 1945.

Encaustic on paper mounted on board, 24 x 18 inches. Private collection.

Plate 17. **Mina Loy,** *Moons I* c. 1932 (dated 1902 on painting). Gouache on board, 20 ⅞ x 30 inches.

Collection Jean Farley Levy.

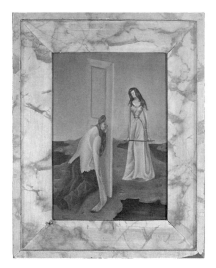

Plate 18. **Max Ernst,** *Stolen Mirror* 1941. Oil on canvas, 26¾ x 59 1/16 inches. Property of Dallas Ernst.

Plate 19. **Leonor Fini,** *The Sleepless Day* n.d. Oil on canvas, 14 x 9½ inches. Collection Jean Farley Levy.

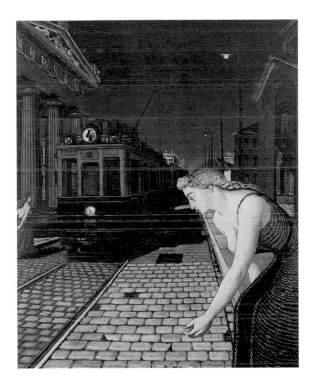

Plate 20. **Paul Delvaux,** *The Tramway* 1946. Oil on canvas, 27 x 23 inches. Private collection.

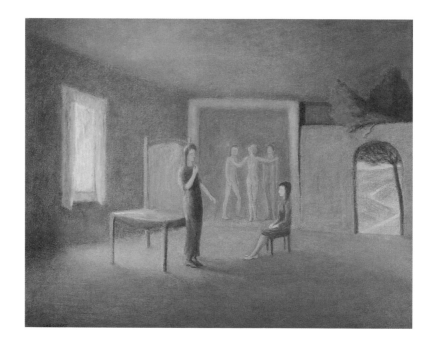

Plate 21. **Gar Sparks, *Untitled (Figures in an Interior)*** 1947. Oil on canvas, 17½ x 21½ inches.

Collection Jean Farley Levy.

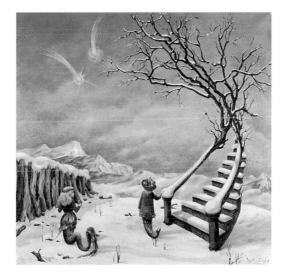

Plate 22. **Dorothea Tanning, *The Truth About Comets and Little Girls*** 1945. Oil on canvas, 24 x 24 inches.

Private collection.

Fetish

Two definitions appear under the heading "Fetichism [*sic*]" in Levy's *Surrealism*. According to the first anthropological "doctrine of spirits embodied in, or attached to, or conveying influence through, certain material objects," the carved wooden torso photographed by Brassaï is a fetish. Arguably—and why should this doctrine apply only to so-called "primitive" objects?—Cornell's daguerreotype construction with a photograph of Julien Levy trapped inside is also a fetish. It represents an art world power, summoned by an aspiring acolyte, through the act of looking deeply into the hand-held object's blue glass covers, past the enclosed grains of sand that drift over the portrait.

The second definition, more pervasive in Surrealism, comes from Freud, and refers "in the terminology of psychoanalysis" to the

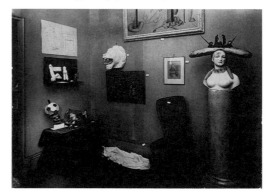

"transference of the libido from the whole object of affection to a part, a symbol, an article of clothing." Thus gloves, hair, shoes, slits, and phalluses recur throughout surrealist imagery replete with fetishistic vigor. The two concepts were so intertwined that Levy represented the term "fetish" in his book with a photograph, taken by Man Ray, of Surrealist art and artifacts in a 1933 exhibition at the Pierre Colle gallery in Paris. Later, when Man Ray offered an exhibition of his own favorite artworks at the Levy Gallery in 1945, he chose the fetishizing title *Objects of My Affection*.

Plate 23. **Man Ray, *Surrealist Exhibition* (at the Pierre Colle gallery)** 1933. Gelatin silver print, 8 x 10 inches.
Collection Jean Farley Levy.

Plate 24. **Lee Miller,** *Untitled* 1931. Gelatin silver print, 11⅝ x 8½ inches. The Art Institute of Chicago,

Julien Levy Collection; Gift of Jean Levy and The Estate of Julien Levy.

Plate 25. **Brassaï, *Torse de Femme (Ciseau)* (*Female Torso/Scissors*)** n.d. Gelatin silver print, 6⅝ x 9 inches.

Collection Jean Farley Levy.

Plate 26. **Tamara de Lempicka, *Le Coquillage (The Shell)*** 1939. Oil on canvas, 16⅛ x 20⅛ inches.

Collection Joseph Zicherman.

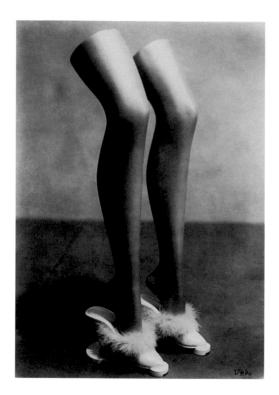

Plate 27. **Umbo,** *Untitled* 1928. Gelatin silver print, 11 ¹⁵⁄₁₆ x 8 ¼ inches. The Art Institute of Chicago,

Julien Levy Collection; Gift of Jean and Julien Levy.

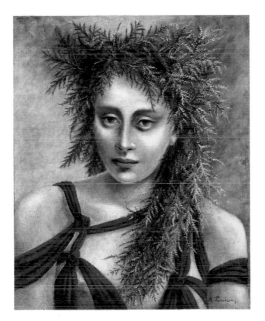

Plate 28. **Dorothea Tanning, *Deirdre*** 1940. Oil on canvas, 21 x 17 inches.

Private collection.

Magic Realism and Neo-Romanticism

Neo-Romanticism and Magic Realism might be considered two of Surrealism's cousins. The Neo-Romantics were a small, loosely affiliated group of painters, based in Paris, who came together during the 1920s through their shared resistance to modernist abstraction, particularly Cubism, which they saw as dehumanizing. Their figurative art returned to Picasso's Rose and Blue periods and the classicizing mode of de Chirico's early metaphysical paintings. In his 1935 book *After Picasso,* James Thrall Soby posed Neo-Romanticism as the dreamy, somnambulant flip side of Surrealism's agitated psychic dream-realities. The Neo-Romantics were first shown in the United States by Chick Austin at the Wadsworth Atheneum, with an exhibition of works by Pavel Tchelitchew, Kristians Tonny, Christian Bérard, and the brothers Eugene Berman and Leonid. Levy would show all of these artists at his gallery. And although they were remarkably prolific—in fashion and theater as well as in art—the Neo-Romantic movement has garnered but a frail reputation. (Curiously, for decades Tchelitchew's huge metamorphic *Hide and Seek* was one of the Museum of Modern Art's most popular paintings, second only to Andrew Wyeth's *Christina's World.*) To a certain extent, the artists were their own undoing. They hated being grouped as Neo-Romantics, and preferred to be known individually.

Levy dabbled in Magic Realism, a style of painting that shared ground with Surrealism, by exhibiting the work of affiliates John Atherton, Paul Cadmus, Ben Shahn, Jared French, and Peter Blume. In the 1943 Museum of Modern Art exhibition catalogue *American Realists and Magic Realists,* Alfred H. Barr, Jr., described Magic Realism as "a term sometimes applied to the work of painters who, by means of an exact realistic technique, try to make plausible and convincing their improbable, dreamlike or fantastic vision." The most passionate

champion was Lincoln Kirstein, who in the same catalogue and in defiance of the rising Abstract Expressionism movement ("All looseness is wasteful"), championed Magic Realism, with its "termite gusto for detail," as *the* school of American painting.

Reality is another matter. When Harold Rosenberg reviewed Julien Levy's 1977 *Memoir of an Art Gallery* for *The New Yorker,* he faulted the book as "considering the period . . . politics-free to an amazing degree." (In short, he accused Levy with being out of touch with reality.) But the pictures Levy exhibited suggest otherwise. For example, Peter Blume's

The Eternal City depicts a jack-in-the-box Mussolini amid the destructive order wrought by fascism in Rome. Paul Cadmus's *Shore Leave,* showing randy seamen and their friends— buff guys and floozies—was typical of the work by Cadmus that was confiscated by the Navy from the Corcoran Gallery of Art in 1934. In 1938, when Levy exhibited Jared French's WPA murals for West Coxsackie, New York, a battle was sparked that raged in the art press over the work's nationalism. (The artist was publicly denounced, in *The Art Digest,* for drawing on French academic models for his American commission.) Levy may not have been a socialist committed to Abstract Expressionism—Rosenberg's preferred reality—but his support of alternatives to mainstream modernism is political in its own right. As a Surrealist, Levy promoted multiple modes of abstraction, many photographies, feminine and masculine sensibilities, high art forms and low, images steeped in Romanticism and those sharpened by Realism.

Plate 29. **Pavel Tchelitchew, *Untitled*** 1941. Watercolor or ink and gouache on paper, 15¼ x 11¼ inches. Private collection.

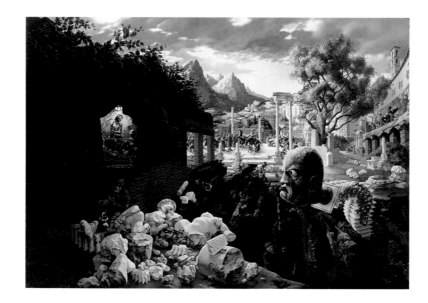

Plate 30. **Peter Blume, *The Eternal City*** 1934–1937. Oil on composition board, 34 x 47⅞ inches.

The Museum of Modern Art, New York; Mrs. Simon Guggenheim Fund, 1942.

Plate 31. **Eugene Berman, *Death in Venice*** 1945. Oil on canvas, 51 x 38 inches.

Collection Richard Louis Brown.

Plate 32. **Paul Cadmus, _Shore Leave_** 1933. Oil on canvas, 33 x 36 inches.

Whitney Museum of American Art, New York; Gift of Malcolm Forbes.

Plate 33. **John Atherton,** *September 27* 1943. Oil on canvas, 36 x 52 inches.

Steve Turner Gallery, Los Angeles.

Photographies

Julien Levy opened his gallery in November 1931 to promote photography and film. His first exhibition, an homage to Alfred Stieglitz, was a retrospective of American photography in its evolution from pictorialism to straight photography. In February 1932, Levy's exhibition *Modern European Photography* posed some alternatives visions. Notably, it represented the Bauhaus teacher László Moholy-Nagy, whose 1920s publication *Malerei, Fotographie, Film* had provided the model for the Harvard Society for Contemporary Art's *Modern Photography* exhibition of 1930, which included X rays and newspaper photographs, and emphasized the experimental possibilities inherent in photography through images of abstraction and documents of scientific research. (The Harvard show was reconfigured in 1932 for the Brooklyn Museum and the Albright Art Gallery with many loans from the Levy Gallery.) In Paris, interest in photography seemed to lie in the act of taking a picture, or what Henri Cartier-Bresson would famously dub "the decisive moment." Levy produced his own manifesto (under the pseudonym Peter Lloyd) for the brochure that accompanied Cartier-Bresson's 1933 gallery exhibition. Lloyd/Levy praised the work as "rude and crude," and commented that "Chaplin has always retained his original camera-man, crude motion and crude chiaroscuro, 'bad' photography in a protest against the banal excellencies of the latest Hollywood films." Lloyd coyly advised Levy to legitimate Cartier-Bresson's "anti-graphic photography. That will demand the greater courage, because you have championed, since the beginnings of your Gallery, the cause of photography as a legitimate graphic art; because you may bring down upon your head the wrath of the great S's [Stieglitz, Paul Strand, and Edward Steichen] of American photography whom you so admire. Yes! Call it ANTI-GRAPHIC PHOTOGRAPHY and work up some virulent enthusiasm for the show. There is no reason why your Gallery should not fight for both sides of a worthy cause." To emphasize the point,

Levy juxtaposed Cartier-Bresson's prints with an exhibition in the back gallery of stock newspaper images and film stills, which he also attempted to sell as examples of applied photography.

Cinematic motion and Surrealist subjectivity are essentially the antithesis of "straight" photography, the official photography in the country during Levy's day. Straight photography rejected the darkroom alchemy of Lee Miller's solarization and Man Ray's abstractly experimental Rayographs and films. It raised a near-moral objection to the constructed imagery of Surrealist photography—to Umbo's mannequins and Maurice Tabard's photomontage—so flagrantly untrue to time, obscuring of reality, distorted by imagination and desire. It discerned fine-art photography from advertising, fashion, and documentary photography. (It did not know what to make of Atget's "documents" of Paris.) And in its essential determination to distinguish the medium as separate from painting and sculpture, the school of straight photography made little room for Joseph Cornell's constructed "daguerreotype portraits" and Salvador Dali's notion that his absurd and meticulous renderings were "snapshots of the mind." Ultimately what made Levy's vision unique was his attempt to embrace all of the above, including straight photography, and to allow photography to imprint itself so immediately on his vision of contemporary art.

Plate 34. **Thurman Rotan, _Untitled_** 1932. Brown-toned gelatin silver print, 4⅝ x 8¾ inches. The Art Institute of Chicago, Julien Levy Collection; Gift of Jean Levy and The Estate of Julien Levy.

Plate 35. **Peter Pulham, *Sphinx with Mask*** c. 1935. Gelatin silver print, 11 x 8¾ inches. Collection Jean Farley Levy.

Plate 36. **Nadar, *Portrait of George Sand*** c. 1865. Albumen silver print, 9⅝ x 7 inches. Collection David Brenman Richardson.

Plate 37. **Jean-Eugène-Auguste Atget,** *Fête du Trône* 1909/1914. Matte albumen print from dry plate negative, 7 x 9¼ inches.

The Art Institute of Chicago, Julien Levy Collection; Gift of Jean and Julien Levy.

Plate 38. **Clarence John Laughlin,** *A Ravaged Door* 1940. Gelatin silver print, 13 x 10 inches. The Art Institute of Chicago,

Julien Levy Collection; Gift of Jean Levy and The Estate of Julien Levy.

Plate 39. **Eli Lotar,** *Untitled* c. 1930. Gelatin silver print, 4¼ x 5⅝ inches. The Art Institute of Chicago,

Julien Levy Collection; Gift of Jean Levy and The Estate of Julien Levy.

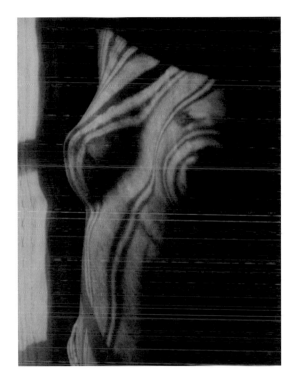

Plate 40. **Man Ray,** *Retour à la Raison* (*Return to Reason*) 1923. Gelatin silver print from motion picture negative,

9¼ x 7⅛ inches. Thomas Walther Collection.

Plate 41. **Man Ray, *Rayograph* (flower and glove form)** n.d. Unique gelatin silver print, 11 x 8¼ inches.

Collection Jean Farley Levy.

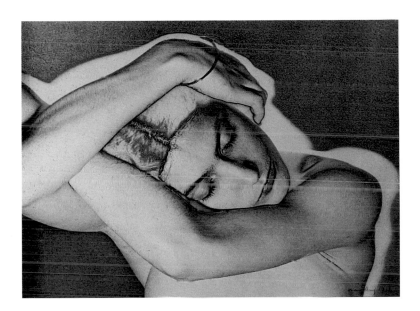

Plate 42. **Man Ray,** *Swana* 1931. Solarized gelatin silver print, 8½ x 11½ inches.

Thomas Walther Collection.

Plate 43. **Joseph Cornell,** *Portrait of Mina Loy (Daguerreotype-Object)* 1936. Assemblage, 5 ½ x 4 ½ x ⅞ inches.

Collection Jean Farley Levy.

Plate 44. **Lee Miller,** *Portrait of Charles Chaplin* n.d. Gelatin silver print, 6¾ x 9 inches. Collection Mrs. Mel Jacobs.

Plate 45. **Remi Lohse,** *Fandance* 1934. Gelatin silver print, 5¼ x 7¾ inches. Collection Jean Farley Levy.

Plate 46. **Henri Cartier-Bresson,** *Valencia, Spain* 1933. Gelatin silver print, 5 15/16 x 7 5/16 inches.

The Art Institute of Chicago, Julien Levy Collection; Special Photography Acquisition Fund.

Plate 47. **Henri Cartier-Bresson,** *Seville* 1933. Gelatin silver print, 6 1/8 x 9 1/4 inches. Thomas Walther Collection.

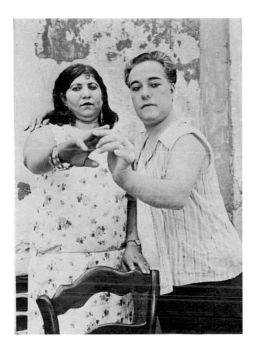

Plate 48. **Henri Cartier-Bresson, *Alicante, Spain*** 1932. Gelatin silver print, 9 ³⁄₁₆ x 6 ⁵⁄₁₆ inches. Thomas Walther Collection.

Plate 49. **Alice Lex-Nerlinger, *Näherin* (*Seamstress*)** c. 1930. Gelatin silver print, 6⅝ x 4¾ inches. The Art Institute of Chicago,

Julien Levy Collection; Gift of Jean Levy and The Estate of Julien Levy.

Plate 50. **Ilse Bing, *Veere, Holland, Masts and Nets in Harbor*** 1931. Gelatin silver print, 8¾ x 11 inches. Thomas Walther Collection.

Plate 51. **Walker Evans, *Untitled (New York City)*** c. 1930. Gelatin silver print, 6¼ x 8¾ inches.

The Art Institute of Chicago, Julien Levy Collection; Gift of Jean Levy and The Estate of Julien Levy.

Plate 52. **Paul Strand,** *Akeley Camera* 1922. Gelatin silver print, 9¾ x 7¾ inches. Collection Jean Farley Levy.

Plate 53. *The New York Times, Untitled* March 17, 1929. Newspaper clipping mounted on paper. Collection Jean Farley Levy.

Plate 54. **Berenice Abbott, _Untitled_ (New York montage, maquette for a photomural)** 1932.

Gelatin silver print, 4⅛ x 8 inches. Thomas Walther Collection.

Play

Games were serious fun for the Surrealists, who enjoyed the pleasures of adhering to and breaking rules. Rules established parameters to occupy the critical mind and allow the imagination free rein to play. Like one big game, the Surrealist revolution, centralized in Paris at a mock bureau, or office, communicating with remarkably official-looking stationery, was conducted along the lines of playful research involving questionnaires, behavioral experiments, and poetic social propositions. Games also provided a structure for the collaborations that characterized the movement, producing some of its most vital impetus in words and pictures. Many of the games were adaptations of Victorian parlor pastimes: parlor antics for parlor revolutionaries, who enjoyed their collections, their libraries, their objects, their love affairs. One cannot help seeing Levy's attraction to the movement as a form of license to break the rules of his bourgeois background, while, as an art dealer carrying on a respectable trade, remaining very much a part of the bourgeoisie. It was, after all, very much a revolution of the mind.

In *Surrealism,* Levy published various examples of games, among them Question/Answer ("What is day?" "A woman bathing nude at nightfall") and If, When ("If there were no guillotine..." "The Wasps would take off their corsets"). His personal favorite was chess, a game which he played frequently with Marcel Duchamp. The latter, who allegedly gave up art for chess, once observed: "From my close contact with artists and chess players, I have come to the personal conclusion that while all artists are not chess players, all chess players are artists."

Plate 55. **Max Ernst, *The King Playing with the Queen*** 1944. Bronze (cast 1954, from original plaster), 38½ inches high, at base 18¾ x 20½ inches, Edition 4/6. The Museum of Modern Art, New York; Gift of D. and J. de Menil.

Plate 56. **Dorothea Tanning,** *The Game of Chess* 1944. Oil on canvas, 17 x 17 inches.

Collection Harold and Gertrud Parker.

Sex and the Sexes

"As beautiful as the chance encounter on a dissecting table, of a sewing machine and an umbrella" (from the proto-Symbolist poet Lautréamont's *Les Chants de Maldoror*) is one of Surrealism's favorite images. Replace the sewing machine with a woman, the umbrella with a man, and the operating table with a bed, and the quintessential Surrealist rendezvous reveals itself to be nothing more, or less, radical than sex, the ultimate creative act. The collective imagery of the Julien Levy Gallery teems with sexual appetite and innuendo, and with pictures of women. Widely objectified by the movement, women were the key to liberating or destroying creative production. "The Disquieting Muse," Levy titled his 1958 essay on Surrealism. In his memoir, he vividly describes his first glimpse, at Atget's studio, of rare nude portraits of a woman with dirty feet—intimate erotica tucked amid the hundreds of views of Paris for which the photographer was known. Levy relates how his early encounters with Duchamp (whose feminine alter ego was Rrose Sélavy) were spent in stimulating discussion over plans to create a life-size mechanical woman, "possibly self-lubricating." The heroine of Duchamp's own art, his *Bride Stripped Bare,* is a lovemaking machine attended to by scores of pitiful little bachelors.

The role of women within Surrealism as both objects and object makers is complex. Some women invented hyperfeminine personas, performative selves, complete with costuming, that were spectacular Surrealist models. At the same time, they felt free to reject the authority of the movement. Frida Kahlo welcomed Breton's interest in her work, and famously told an interviewer for *Vogue,* "I never considered myself a Surrealist until André Breton told me I was one." Elsewhere, she referred to him as a "big caca." The dramatic Leonor Fini also never joined the official ranks, preferring to ally herself with other rebels, Georges Bataille and Jean Genet. On the other hand, the artist Dorothea Tanning, who refuses to participate in women-only shows, maintains the view that the women of Surrealism were, like the men, active in a movement vividly stirred by sex.

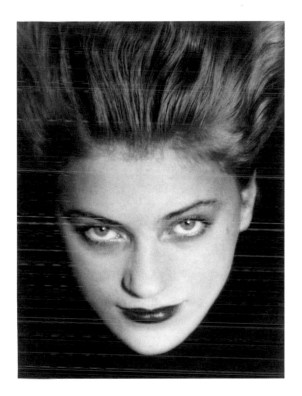

Plate 57. **Man Ray, *Portrait of Lee Miller*** c. 1930. Gelatin silver print, 8¹⁵⁄₁₆ x 6¾ inches. Thomas Walther Collection.

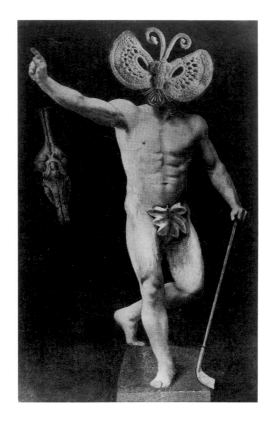

Plate 58. **Max Ernst,** *La Santé par le Sport* (*Health Through Sport*) c. 1929.

Photographic enlargement of photo montage, 39⅜ x 23⅝ inches. Collection Jean Farley Levy.

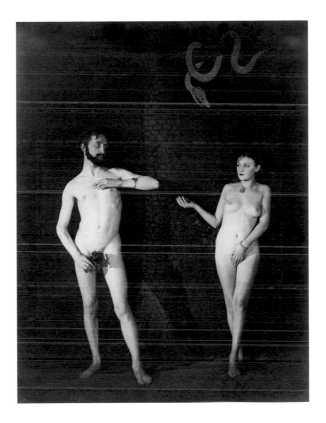

Plate 59. **Man Ray, *Cine-Sketch: Adam and Eve*** 1924–1925. Gelatin silver print, 11 x 8½ inches.

Collection Jean Farley Levy.

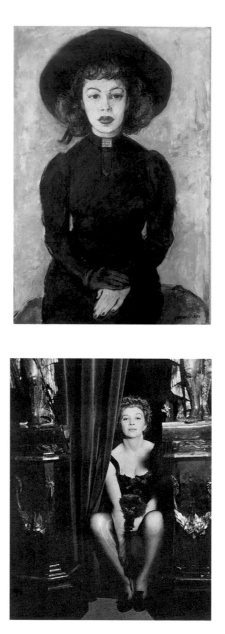

Plate 60. **Maurice Grosser,** *Jane Bowles* 1937. Egg tempera and oil on canvas, 35¼ x 23¼ inches.

Private collection; formerly Collection Paul J. Sanfaçon.

Plate 61. **Dora Maar,** *Leonor Fini with Cat* 1936. Ferrotype, 11¾ x 9 inches. Collection Jean Farley Levy.

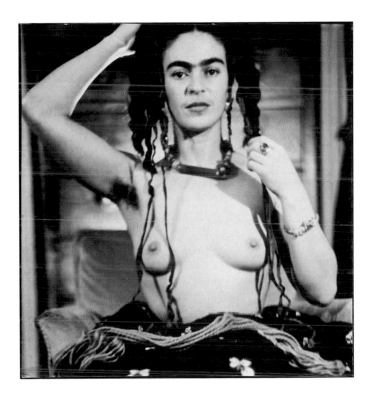

Plate 62. **Julien Levy,** *Untitled (Portrait of Frida Kahlo)* 1938. Gelatin silver print. Collection Jean Farley Levy.

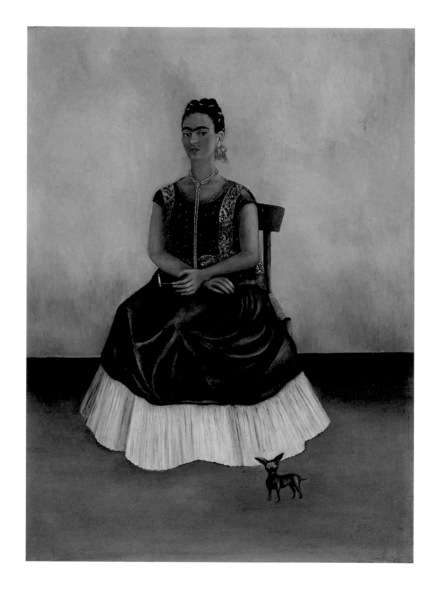

Plate 63. **Frida Kahlo,** *Itzcuintli Dog with Me* c. 1938. Oil on canvas, 27 x 20 inches. Private collection.

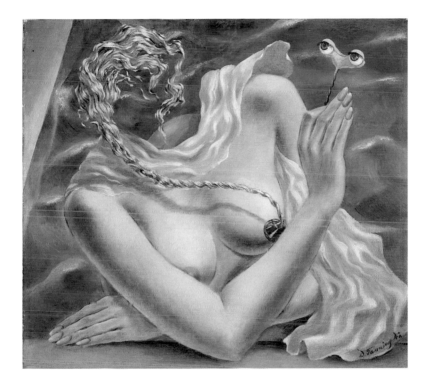

Plate 64. **Dorothea Tanning,** *Voltage* 1942. Oil on canvas, 10¾ x 12 inches. Collection Arno Schefler.

Surrealism

Julien Levy gained entrée to Surrealism through *91, rue de Turenne,* an
Atget photograph of an empty staircase with an undulating wrought-
iron banister that Levy saw reproduced in the December 1, 1926, issue
of *La Révolution Surréaliste.* Levy was struck by the resemblance between
the photograph and a painting by Pierre Roy entitled *Danger dans l'Escalier*
of a snake slithering down a staircase railing. Levy observed in each an
expression of suppressed foreboding and expectancy that he character-
ized as "surrealist." But he granted to the serpentine Atget the privilege
of achieving this effect by means closer
to everyday reality than those of the Roy
with its escaped reptile. The fact that
his comparison stems from moods and
images, not medium or style, is significant
of Levy's aesthetic, which was literal-
minded and indiscriminate: he always took
his Surrealism where he found it.

 This section is devoted to Levy's 1932 exhibition *Surréalisme.*
With works by Salvador Dalí, Max Ernst, and Pablo Picasso, Levy followed
the leadership of André Breton, whose definition of the Paris-based move-
ment was quoted in the brochure. Yet Levy made some original choices
for his New York debut of Surrealist art, including Jean Cocteau, an artist
Breton opposed, and Herbert Bayer, a Bauhaus artist experimenting with
surreal images. The checklist announced photographs, montages, and
under the heading "Potpourri," Surrealist objects. And in addition to the
unexpected proto-Pop inclusion of tabloid newspaper pages comically
splashed with the sex scandal of the day, Joseph Cornell, making his art
world debut, showed some of his first collages and a Glass Bell.

SURREALISM

PLATES

154

Plate 65. **Jean-Eugène-Auguste Atget, *91, rue de Turenne*** 1911. Albumen print, 8 x 7 inches. The Art Institute of Chicago, Julien Levy Collection; Special Photography Acquisition Fund.

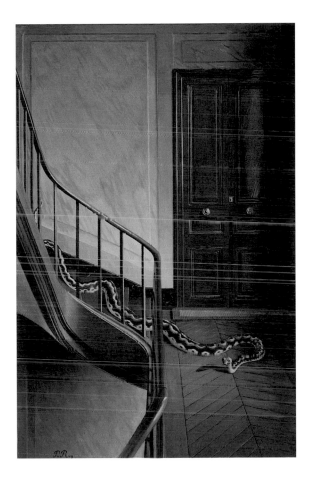

Plate 66. **Pierre Roy,** *Danger dans l'Escalier* (*Danger on the Stairs*) 1927 or 1928. Oil on canvas, 36 x 23⅞ inches.

The Museum of Modern Art, New York; Gift of Abby Aldrich Rockefeller.

Plate 67. **Roger Parry, image from Paul-Léon Fargue's special-edition artist's book *Banalité*** 1930.

Photogravure, 15¼ x 11¼ inches. Collection Jonathan Levy Bayer.

Plate 68. **Maurice Tabard, *Still Life with My Shoe*** 1929. Gelatin silver print, 9 x 6⅝ inches. The Art Institute of Chicago,

Julien Levy Collection; Gift of Jean Levy and The Estate of Julien Levy.

Plate 69. **George Platt Lynes with Julien Levy, *Untitled*** c. 1931. Gelatin silver print, 6¹¹/₁₆ x 5 inches. The Art Institute of Chicago,

Julien Levy Collection; Gift of Jean Levy and The Estate of Julien Levy.

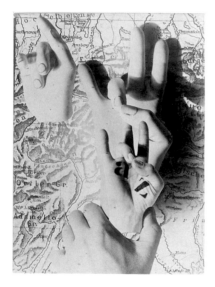 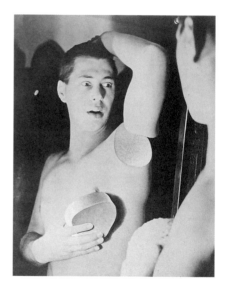

Plate 70. **Herbert Bayer,** *Untitled (A–Z)*, **from the series** *Fotoplastiken* 1932. Gelatin silver print, 3 x 2 inches.

Collection Jean Farley Levy.

Plate 71. **Herbert Bayer,** *Untitled (Self-Portrait)* c. 1932. Gelatin silver print, 15 ¼ x 11 ½ inches. Thomas Walther Collection.

Plate 72. **Joseph Cornell,** *Untitled ("Minutiae")* c. 1932. Four assemblage objects, various dimensions. Collection Mark Kelman.

Plate 73. **Max Ernst,** *"...or down there, that indecent Amazon in her little private desert..."* 1929–1930.

Paper collage, 7 ¾ x 7 ⅝ inches. Collection Timothy Baum.

Figure 37. **Jay Leyda, *Portrait of Julien Levy*** c. 1932. Gelatin silver print, 5 x 4 inches. Collection Jean Farley Levy.

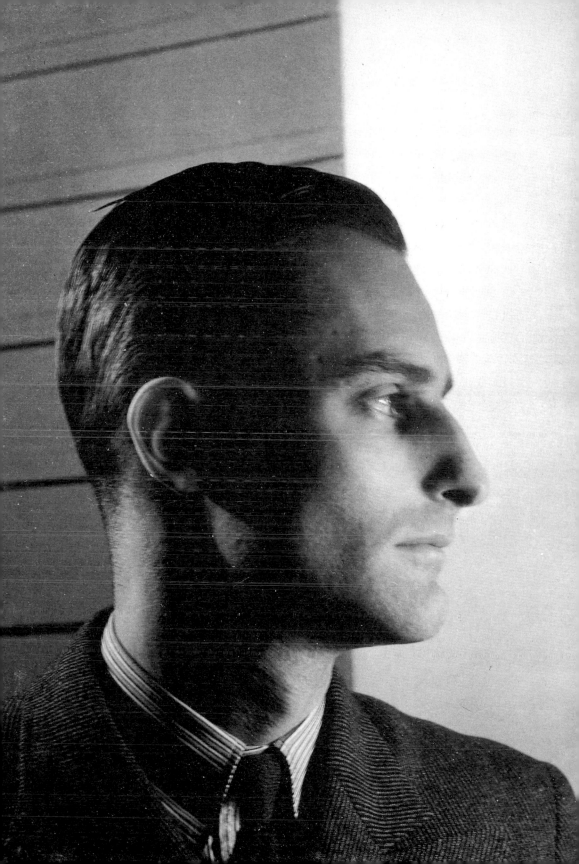

Reminiscences

Compiled by Lisa Jacobs

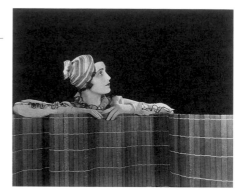

Julien was a genius. He had the nerve to have a modern gallery— the first modern gallery. Julien was the first to show the Surrealists. At first it was going to be a bookshop, but the photographers made such marvelous things that he decided on a gallery for photography. Stieglitz gave him work for the first show. We would go to Europe because we felt we could find truly modern art there. We talked over the idea for a gallery endlessly. Of course, it was the Julien Levy Gallery but I was his partner. I was a marvelous slave. We entertained a great deal. People would come over after the theater. So many people would turn up, everyone came in black tie, it was the way it had to be done in those days. New York had terrific style.

— JOELLA LEVY BAYER

He was a dark, swashbuckling figure... an immensely seductive man. He had a kind of saturnine good looks, a handsome head, and a very low, most seductive voice. He was a great ladies' man.

I remember hearing that he was always terribly up against a wall because his father wouldn't give him money until quite late in the game. He was always desperate about his bills, about not being able to pay his artists and not being able to pay for the gallery. It was only after the war that his father finally relented and realized that he was not going to persuade Julien to go into the family business. He gave that up and then helped Julien with money.

Another thing I remember is that he was very hurt that artists would leave him. Julien gave the first Giacometti show in New York; then Giacometti

Figure 38. **George Platt Lynes, *Joella Levy* (modeling hat and gloves)** c. 1930. Collection Joella Levy Bayer.

left him. I think Julien felt terribly resentful. When Max Ernst married Peggy Guggenheim, Peggy took him for her gallery, and then later, after he divorced Peggy, Max came back to Julien. Julien would put his heart and enthusiasm into promoting an artist, and then the artist would leave. I think he often felt ill treated.

Much later, in Paris... Julien and Jean lent me for a brief time their little apartment. Julien by then, as I believe happens to people who are dried out, was completely diminished; he was an empty shell of his former self. Probably Jean saved his life by stopping him from drinking, but the dashing, amusing ladies' man was completely withdrawn.

I can't remember precisely when I first met Julien; I was a sort of younger member of his group. We were friendly enough that I used to have dinner with him. I probably met him first at his gallery. At that time, he was utterly disconsolate because Muriel had left him. He was drinking heavily.

— ROSAMOND BERNIER

W hen I was doing my military service in Le Bourget, and when I was not under military punishment, Harry and Caresse [Crosby] took me to Le Moulin, where I met Julien. The first glance was of sympathy, but when he opened his mouth I thought he was making a caricature of an American accent. In spite of this we became close friends, and it was he who did my first exhibition in New York after one year of taking photographs.

Off and on, I saw Julien with the same intimacy. He was a jewel in himself. Frankly I always enjoyed shooting but never printing. In spite of this, I gave him some prints done by myself, a real collection, since I never printed again. I also gave some to Beaumont Newhall and Lincoln Kirstein and a very few other friends. The rest which is on the market now has never been printed by myself but by my lab for press purpose or exhibitions.

—HENRI CARTIER-BRESSON

I first met Julien Levy when I was assigned by *Life* to cover the 1939–1940 New York World's Fair and Julien was running the "Dreams of Dalí" (or some such title) show there. He had a woman diver who entered a huge glass box and swam around amid Dalíesque objects. I was never sure if the diver was not his wife, Muriel. Years later, I kidded Julien and Muriel about the crazy diver I'd photographed, and they exchanged embarrassed glances, to my consternation.

—DAVID SCHERMAN

There was a breed of man, born around the turn of the century of families made affluent in the aftermath of the Civil War, Yankee or German Jewish, educated at Harvard in the humanities and connoisseurship. They were neither brought up nor educated to make money, which their families had in greater or lesser abundance. They became educators, publishers, museum

Figure 39. **Attributed to George Platt Lynes,** *Untitled* (A "liquid lady" from Salvador Dali's *Dream of Venus* pavilion at the 1939 New York World's Fair, surrounded by Edward James, Salvador and Gala Dali, and Julien Levy). Courtesy Young-Mallin Archive.

directors, art collectors, and dealers, but also scholars, and above all, gentlemen. The glorious and lamented brigade included the likes of Wright Ludington, Joseph Pulitzer, Edward Warburg, Lincoln Kirstein, Henry McIlhenny, Henry Clifford—and Julien Levy.

There were evenings in Paris in the late fifties and sixties that would progress from Jean and Julien's tiny Left Bank *entresol,* in which I could barely stand up straight, to a Chinese restaurant behind Saint-Germain-des-Prés, and thence to Julie and Man Ray's studio-bedroom behind Saint-Sulpice; and whereas Man Ray bemoaned his yesterdays, Julien always talked about tomorrow.　　　　　　　　　　— RICHARD L. FEIGEN

Suddenly Surrealism has become fashionable, and all the forgotten leaders are now becoming icons: Man Ray, Marcel Duchamp, Max Ernst— and now, at last, Julien Levy, friend to all.

My husband Mel and I first met Jean Levy at a vernissage of William Copley's paintings at the Alexander Iolas Gallery in New York, around 1959. That was Julien's reentry into the art world, a world he had left behind when he closed his gallery and moved to Connecticut—and, I guess, started drinking in a reclusive sort of way.

We loved to be invited up to Bridgewater for the weekend. It was exciting to meet all the artists and writers who had settled in that area. Julien could not have been too much of a recluse, because he introduced us to such literary icons as Van Wyck Brooks and Norman Mailer. Life up there was stimulating. We went to a costume party at the neighbors'—Julien dressed as a satyr.

Figure 40. **Man Ray, *Muriel Levy*** c. 1944. Courtesy The Man Ray Trust.

The interior of the Bridgewater farmhouse was filled with art—photographs, paintings, books, humorous gadgets. I remember the Levy kitchen: Julien had taken all the miniature reproductions of Marcel Duchamp's creations from his famous *boîte-en-valise* and suspended them on a string across the ceiling. It was certainly an interesting way to view Marcel's retrospective.

Julien was a pixie. He loved telling me anecdotes he thought would shock me about his affairs and all the fun he had in Paris in the thirties. He related stories about his friendship and romance with Lee Miller. In fact, he claimed that he was the one who took Lee Miller away from Man Ray.

Julien was a gem. I feel lucky to have known him.

— ROZ JACOBS

I first met Julien Levy at the house of Kirk and Constance Askew, whose Sunday gatherings were a meeting place for the New York art world—painters, musicians, some famous, some not yet well-known. I heard a very young Leonard Bernstein play the piano there, and Julien, too, was a regular. I was in my twenties and had never had a job, so when Julien asked me if I'd like to work in his gallery I jumped at the chance. I had no qualifications to speak of, but the truth was that he liked pretty girls, didn't much care about secretarial skills, and paid almost nothing—twenty dollars a week I think it was. I didn't care.

It was an exciting place to work, a headquarters for the Surrealists, all of whom were friends of Julien's and many of whom were refugees from Paris, waiting out the war: Max Ernst, Marcel Duchamp, Yves Tanguy, Eugene

Figure 41. **Jonathan Levy Bayer, Julien Levy's collection of works by Cornell, books, and other objects in his Connecticut home** c. 1960. Collection the photographer.

Berman, later his brother Leonid, and one or two young Americans Julien was nursing along, like Joseph Cornell. The Americans especially sold poorly, and Julien more or less kept them on retainers, deductible when a sale was made. You could have bought a Cornell box for fifty dollars. I, of course, didn't have fifty dollars. For me, the point was the artists themselves, who dropped in to chat, have a drink in Julien's apartment upstairs, or in the case of Marcel Duchamp, play chess with Julien.

I was very much in awe of the Europeans and, typing away with four fingers in the back room, never was on close terms with any of them—except the Berman brothers, who did become friends. Still, there they were, and Julien, who was a great gossip, would recount to me their lives and loves, so that I knew more about them than I imagine they would have liked.

Our clientele could be glamorous, too. One day, Julien told me we were expecting Garbo, escorted by her "little man," as she called her mentor, George Schlee. Julien warned me to keep out of the way and not to stare. But when I begged at least to be allowed to bring in the pictures she wanted to see, he said I could. I was so nervous I managed to put a dent in a Dalí I was bringing out of the storeroom, and naturally I couldn't help a long look at the glorious face. Julien was not pleased, and he ordered me back to my lair. The Dalí cost quite a bit to repair, too. But never mind. I had my moment when, as she was leaving, Garbo leaned into the doorway and said in that unforgettable voice, "Good-bye, and thank you."

Julien doesn't give me credit in his memoirs, but I believe I was the one to call his attention to Arshile Gorky, then living in poverty and not being shown in any gallery. I happened to know Gorky's wife, whose parents, friends of my parents and very stuffy people, had been against her marriage to an unknown and penniless painter. My mother and I had taken her side, and as a result we saw something of them. One evening they had us to dinner at his studio in Union Square, and there we saw what we rightly judged a

dazzling array of pictures. He was in the process of changing from his rather derivative and rigid early style to his own highly original version of Abstract Expressionism. The next day, I rushed to the gallery and informed Julien that I had discovered a painter he must show at once. But when he realized I was talking about Gorky he was condescending. "One forgets how young you are," he said. "Gorky's been around for years and he doesn't interest me."

Now, it has to be said that Julien did rather miss the boat on Abstract Expressionism. He showed Matta, who was a forerunner, but he ignored Pollock and Rothko and the other Americans who were being promoted by Peggy Guggenheim, for one. Gorky apart, he bet on the Surrealists and the Neo-Romantics, and he seems to have bet wrong. I don't know when he eventually changed his mind about Gorky. It can't have been my enthusiasm that moved him. Still, I was the one who urged him to go and look for himself, and he did become Gorky's dealer. **— ELEANOR PERÉNYI**

I met Julien in the fall of 1975 in Lacoste, a medieval hilltop village in the Vaucluse. The road was paved only along a main street, consisting of a bakery, general store, post office, and café. Then it turned to dirt as it wound up a hill, past houses with worn archways and tiled roofs, roosters and pots of geraniums, to the imposing ruins of an infamous château.

There were a couple of interesting twists to this village, quite appropriate given Julien's aesthetic. A number of the stone buildings had been converted into a campus for twenty-five college students, who were tucked in wherever they could be. Some of the girls slept in the ovens of the old *boulangerie.* The chapel at the base of the château was used as a dining room. Most of the students were female, predominantly from Sarah Lawrence. Overlooking this unorthodox academy was what was left of the château of the Marquis de Sade.

Into this world, fecund with nature, surrounded by melons ripening in fields, grapes heavy on vines, and figs swelling on trees, these students had

come for a three-month art program. Besides studio courses, sculpting in the limestone quarry, French, and poetry, they had the chance to take a dream seminar taught by Julien. Extracurricular activities included meeting local farmers in search of international adventure at the café, and bacchanals with wine and wreaths of flowers around the swimming pool.

When I look back on that fall, the experience itself seems more surreal than the class Julien taught, but that had a special quality, too. Raconteur extraordinaire, gravel-voiced, idiosyncratic and undisciplined, Julien adjusted the focus of his seminar toward his passion, film. When he opened his gallery in the thirties, he had to concentrate on painting because there was no chance then of making money from his two great loves, film and photography.

And so the Dreamfilm evolved. Students collected their dreams, and read them in class, and finally, one was selected: Kit's dream. Kit starred. A small, old-fashioned bathtub was located, and I can still see her rising from a crouched position, veiled by her knee-length hair, red rose in hand—Julien enthusiastically behind the camera. Lowell's line comes to mind, "All life's grandeur is something with a girl in summer."

Julien's home in nearby Bonnieux, where I was welcomed on weekends, was a magical haven. Man Ray's Lips, *À l'Heure de l'Observatoire— Les Amoureux,* rose in greeting by the front door. A Gorky drawing watched us at the kitchen table, where Julien played solitaire, read my tarot, passed snuff, and recited Baudelaire. The rooms were a mixture of antiques, Orientals, African prints, and arresting *objets*—in the guest bathroom, on a shelf by the toilet paper, was a box of plastic baby dolls and another full of tacks with one of Ingres's odalisques pasted in as the background. Music of all sorts filled the house: Chinese, calypso, Renaissance, jazz. The conversation, too, was often non sequitur, though always urbane, featuring Julien's reminiscences, double entendres, and puns.

"Confusing as I like to be, and strange as it may seem," said Julien on a field trip to Cézanne's studio in Aix, "I am confused by undefined

emotion." At seventy, Julien the aging trickster had a vulnerability about him. Musing on his past, alternating between French cigarettes and his pipe, he said his only regret was that his father had told him he would be a bad business-man and, "damn it, he was right." An entry in

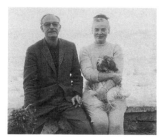

my journal from then reads: "He suffers from guilt and recurring images of what his projected new gallery would be like." Gorky's suicide haunted him.

Jean, his third wife, was his champion. She liked to say she had picked him up out of the gutter and saved him from his past. As bright and bold as the black and yellow print she had selected for the sheets on the guest bed, she managed Julien and contributed special touches: the boxes in the bathroom were hers, as was the trademark wrapping paper for gifts (she pasted photos from magazines together, sliced thin strips for ribbons, added an arbitrary touch like a shoe buckle for a bow).

I will always be indebted to Julien for the support and kindness he showed me during those three months. He nurtured my self-confidence, reading the poems I was writing when I should have been painting, and pronouncing me a poet. Although that moment and those poems are long past, the sense of jubilation and validation is still with me.

Often that fall we played the surrealist game Exquisite Corpse, in the chapel. The game, in which each player draws on his fold of an accordion-pleated sheet of paper without seeing the drawings to which it will connect, seems to me an apt metaphor for the progression of a life looked at in retro-spect. Just so, almost twenty years after I met Julien in Provence, a chain of associations led me to his second wife, Muriel Streeter, in Tucson. She became a special friend until her recent death. Her recollections of their tumultuous life together brought Julien close again and confirmed his continued presence. I look forward to other squiggles on future folds that will reveal my connec-tion to him.

—CITA SCOTT

Figure 42. **Jonathan Levy Bayer, *Julien and Jean Levy in France*** c. 1970. Collection Jean Farley Levy.

Their house in Bridge water was a small one in the middle of a meadow. They had one, two, three, maybe four small rooms downstairs and a couple of bedrooms upstairs.... [In] these few rooms Julien had the most fabulous collection of little *objets d'art,* wonderful stuff. He'd have a pornographic postcard that would be the best pornographic postcard you ever saw in your life. He'd have

a figurine two inches high, carved out of God knows what, that was unbelievably beautiful. He'd have a Joseph Cornell tucked in a little alcove and another little one near the bathroom sink. It was a little like being in a dollhouse, filled with wonders.

Julien was not an easy man to love. But I think I have some real love for him, because he had one gift he gave you. He was a terribly stingy, quirky, odd, offbeat man in about every way but one. Which is that he had wonders to offer. Little wonders in his house, and intellectual wonders. He was extraordinarily well read, and quirkily read, which was a great advantage because he read little books in little corners, books that no one else had read, and he could apply them to whatever you were talking about. So he really belongs to a genius that is now almost gone from the earth. People like Meyer Schapiro, for instance, who no matter what you were talking about, no matter what subject came up, always could quote from memory a text that was relevant to what you were talking about that was wonderfully perceptive, and Julien was that way.

Figure 43. **Jonathan Levy Bayer, Julien Levy's collection in his Connecticut home** c. 1960. Collection the photographer.

Julien's knowledge was so comprehensive that I cannot remember having the same set conversation with him twice, which was one of the wonders of knowing him. He didn't need themes. Most people have to enlarge on a theme that is understood between them and another person. Julien was always all over the place, in a comprehensive fashion. That is, it would probably take twenty years to begin to understand the topography of his mind, but you knew there was one. He had his own worldview, if you will, and everything that he read, that he enjoyed, fit into it, since his mind was always taking leaps—because he was nothing if not surrealistic. If you were talking about baseball he'd very quickly be talking about rocket ships, because he'd see a connection that no one else would see.　　**— NORMAN MAILER**

I was very fond of Julien. We met at Harvard through the Harvard Society for Contemporary Art. I knew Lincoln Kirstein; Julien and I were classmates. I again met up with Julien in 1930 or 1931 in Berlin. He was fascinated by gay nightlife there—it didn't exist anywhere else in the world at the time. I took him to gay bars, and like a good boy, he danced with the boys, but it never went any further than that. The main thing that interested him was art.

In 1931, I founded a society for "Refusés" architects. It was the depths of the Depression, and Edgar, Julien's father, gave us the storefront space in one of his buildings in Manhattan. Julien was very enthusiastic and helped out. It was a nice period when you could go off and do things like that on your own.

Julien was a marvelous person. I knew Joella better. She was so beautiful. Julien went on to Surrealism, and he carried the flag until the Museum of Modern Art caught on. We give credit to him for establishing a home for Surrealism in America.　　**— PHILIP JOHNSON**

Chronology of Exhibitions

Compiled by Lisa Jacobs

The following is a comprehensive list of exhibitions held at the Julien Levy Gallery between 1931 and 1949. The gallery changed address several times during its eighteen-year history, as indicated below.

Julien Levy is known for having given first exhibitions to an impressive number of now famous artists. Unless "in New York" or "in the United States" is specified, "first solo show" indicates the artist's first-ever individual exhibition. For group shows, names of participating artists are provided when known, in most cases as they appeared on gallery announcements. Exhibition titles, likewise, are given as they appeared on these announcements. In many but not all instances, mention is made of the designers of announcements, as well as the authors of essays, which were often included.

A question mark indicates that a precise date could not be verified. One known exhibition is not listed, as the year could not be documented: *From the Julien Levy Collection—Photographs in Portfolio* was held in March sometime between 1943 and 1949, while the gallery was located at its final address.

602 MADISON AVENUE

1931–1932

November 2–20

American Photography Retrospective Exhibition: Mathew Brady, Gertrude Käsebier, Charles Sheeler, Edward Steichen, Alfred Stieglitz, Paul Strand, Clarence White. Arranged with Alfred Stieglitz.

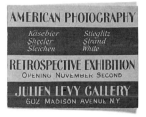

November 21–December 11

Massimo Campigli, Paintings. First solo show in the United States.

December 12, 1931–January 9, 1932

Photographs by Eugène Atget and Nadar (Gaspard Félix Tournachon).

January 9–29

Surréalisme: Eugène Atget, Herbert Bayer, Jacques-André Boiffard, Jean Cocteau, Joseph Cornell, Salvador Dalí, Max Ernst, Charles Howard, George Platt Lynes, Man Ray, László Moholy-Nagy, Roger Parry, Pablo Picasso, Pierre Roy, Maurice Tabard,

Umbo, Unknown Master, Jean Viollier. Announcement cover designed by Joseph Cornell.

During this exhibition, the gallery held its first film screening. The evening of avant-garde film included Fernand Léger's *Ballet Mécanique,* Jay Leyda's *A Bronx Morning,* and Man Ray's *L'Étoile de Mer.*

February 1—19
Walker Evans and George Platt Lynes.

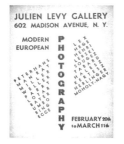

February 20—March 11
Modern European Photography: Herbert Bayer, Ilse Bing, Brassaï (announced as "Halesz"), Ecce Photo, Walter Hege, Florence Henri, André Kertész, Helmar Lerski, Alice Lex-Nerlinger, Eli Lotar, Man Ray, Lee Miller, László Moholy-Nagy, Oscar Nerlinger, Roger Parry, Walter Peterhans, Emmanuel Sougez, Maurice Tabard, Umbo, Peter Weller.

March 12—April 8
Eugene Berman, Drawings and Paintings. First solo show in the United States.

April 9—May 30
Photographs by Man Ray. First solo photography show in New York. Announcement essay by Raoul Roussy de Sales.

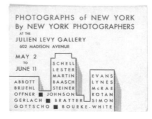

May 2—June 11
Photographs of New York by New York Photographers: Berenice Abbott, Kurt Baasch, Margaret Bourke-White, Maurice Brattner, Anton Bruehl, Walker Evans, Arthur Gerlach, Samuel Gottscho, Johnson, Lester, George Platt Lynes, Wendall McRae, Ira Martin, Mortimer Ottner, Thurman Rotan, Sherrill Schell, Stella Simon, Ralph Steiner.

May 12—June 11
Alexander Calder, Mobiles.

Summer (?)
Modern Photography.

1932—1933

September 26—October 15
Photographs by Berenice Abbott.

October 15—November 5
Exhibition of Portrait Photography, Old and New: Berenice Abbott, Antoine Samuel Adam-Salomon, Bachrach, Bengue, Mathew Brady, Julia Margaret Cameron, Carjat, Frank Eugene, Arnold Genthe, David Octavius Hill, Pinchos Horn, George Hoyningen-Huene, Gertrude Käsebier, Helmar Lerski, Jay Leyda, George Platt Lynes, Pirie MacDonald, Man Ray, Lee Miller, Lucia Moholy, Nadar, Dorothy Norman, Reutlinger, Sherrill Schell, Stella Simon, Edward Steichen, Ralph

Steiner, Alfred Stieglitz, Vandamm, Clarence White.

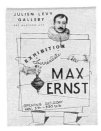

November 5–December 3 Exhibition Surréaliste by Max Ernst. First solo show in the United States. Announcement designed by Ernst.

November 17, 5:00 p.m. Luis Buñuel and Salvador Dalí's *Un Chien Andalou*. First screening in the United States. Second film screening at the gallery.

November 26–December 30 Etchings by Pablo Picasso: Illustrations for "Le Chef d'Oeuvre Inconnu." Objects by Joseph Cornell: Minutiae, Glass Bells, Shadow Boxes, Coups d'Oeil, Jouets Surréalistes. Cornell's first solo show.

December 30, 1932–January 25, 1933 Paintings by Charles Howard. First solo show in the United States. Announcement cover designed by Howard, essay by Louis Bouche.

Lee Miller, Exhibition of Photographs. Only solo show during the artist's lifetime. Announcement essay by Frank Crowninshield.

January 26 (one day only) The Carnival of Venice: Photographs by Max Ewing. Announcement essay by Gilbert Seldes.

January 28–February 18 Paintings by Mina Loy. First solo show in the United States. Announcement cover designed by Loy; her poem "Apology of Genius" reprinted on announcement.

Luke Swank, Photographs of the American Scene.

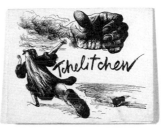

February 24–March 25 Kurt Baasch, Photographs.

Pavel Tchelitchew, Drawings. First solo show in the United States.

March 25–April 22 Eugene Berman. Luminators by Russel Wright.

April 26–May 20 Georges Rouault, Etchings.

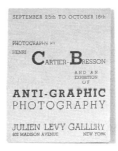

1933–1934

September 25–October 16 Photographs by Henri Cartier-Bresson and an Exhibition of Anti-Graphic Photography.

First solo show. Announcement essay
by Peter Lloyd (pseudonym of Julien Levy).

October 14 – 30
Stojana, Sculpture, Drawings, Paintings.
Announcement essay by Walter Pach.

November 2 – 18
Twenty-five Years of Russian Ballet from
the Collection of Serge Lifar: Paintings,
Drawings, Designs, Models: Leon Bakst,
André Bauchant, Alexandre Benois,
Christian Bérard, Georges Braque, Jean
Cocteau, Paul Colin, Giorgio de Chirico,
André Derain, Max Ernst, Naum Gabo,
Natalia Goncharova, Juan Gris, Constantine
Korovine, Michael Larinov, Marie Laurencin,
Fernand Léger, Louis Marcoussis, Henri
Matisse, Joan Miró, Amedeo Modigliani,
Eugene Mollo, Pablo Picasso, Pedro Pruna,
Isaac Rabinovitch, Francis Rose, Georges
Rouault, Prince Alexander Schervashidze,
José María Sert, Dimitri Steletzky, Leopold
Survage, Pavel Tchelitchew. Announcement
foreword by Serge Lifar.

November 21 – December 10
Salvador Dalí. First solo show in the United
States. Announcement card designed
by Dalí.

December 12, 1933 – January 3, 1934
Objects by Joseph Cornell, Posters by

Toulouse-Lautrec, Watercolors by Perkins
Harnly, Montages by Harry Brown.

January 4 – 31
Emilio Terry, Architecture. Announcement
essay by Waldemar George.

February 6 – March 3
Remi Lohse, Photographs. Announcement
essay by M. F. Agha.

Helen Sardeau, Sculpture.

March 6 – 24
Marc Perper, Paintings.

April 3 – 28
Salvador Dalí, Drawings and Etchings
to Illustrate Lautréamont's *Les Chants de
Maldoror*.

April 21 – 28
Wynn Richards, Photographs.

1934 – 1935

October 1 – October 13
Fifty Photographs by George Platt Lynes.
Announcement essay by Glenway Wescott.

October 22 – November 2
Eight Modes of Painting: Survey of
Twentieth-Century Art Movements:
Christian Bérard, Eugene Berman, Georges
Braque, Heinrich Campendonk, Salvador
Dalí, Otto Dix, Katherine S. Dreier, Marcel
Duchamp, Louis Eilshemius, Max Ernst,

Juan Gris, Childe Hassam, Hilaire Hiler, Karl Hofer, Wassily Kandinsky, Paul Klee, Leonid, Jean Lurçat, Henri Matisse, Jean Metzinger, Joan Miró, Piet Mondrian, Claude Monet, Pablo Picasso, Jean Renoir, Henri Rousseau, Pierre Roy, Charles Sheeler, Pavel Tchelitchew, Arnold Wiltz. Curated by Agnes Rindge, under the auspices of the College Art Association.

November 3–19
Corinna de Berri, Paintings.

November 21–December 10
Paintings by Salvador Dalí. Announcement cover designed by Dalí.

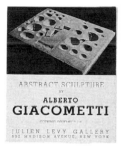

December 1, 1934–January 1, 1935
Abstract Sculpture by Alberto Giacometti. First solo show in the United States. Giacometti's *On Ne Joue Plus* reproduced on announcement.

December 12–31
Pavel Tchelitchew, Paintings and Drawings. Pen-and-ink drawing by Tchelitchew reproduced on announcement.

January 5–31, 1935
Emilio Amero, Paintings, Watercolors, Drawings, Photographs. Announcement cover designed by Amero, essay by Jean Charlot.

January 12 (one day only)
Two Portraits by Salvador Dalí: *Mrs. Clarence M. Wooley* and *Edward Wassermann.*

February 26–March 18
Leonid, Paintings. First solo show in the United States. Announcement essay by Waldemar George.

March 19–April 1
Keith Martin and Charles Rain.

April 2–22
Eugene Berman.

April 23–May 7
Documentary and Anti-Graphic Photographs by Henri Cartier-Bresson, Walker Evans, and Manuel Alvarez Bravo.

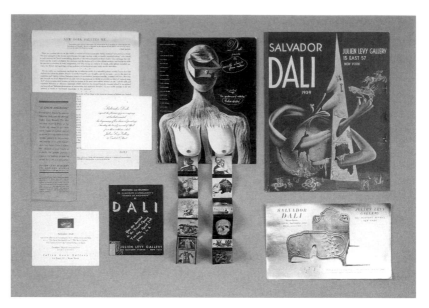

May 7–31

Jean Cocteau, Drawings. Announcement
card designed by Cocteau.

May (?)

Bernard Sanders, Etchings and Drawings.
Announcement card designed by Sanders.

1935–1936

October 1–15

Brett Weston, Photographs. Weston
photograph reproduced on announcement,
essay by Merle Armitage.

October 15–31

Juan Gris. Announcement card designed
by Gris.

Etchings and Monotypes by Marcel Vertes.
Announcement card designed by Vertes.

November 1–19

Abraham Rattner, Paintings. First solo
show. Announcement essay by Pierre
Reverdy.

November 19–December 17

Leonid. Announcement cover designed
by Leonid.

January 3–20, 1936

René Magritte, Paintings. First solo show

in the United States. Announcement essay by Paul Nouge, poem by Paul Éluard (translated by Man Ray).

January 28–February (?)
Massimo Campigli. Announcement cover designed by Campigli.

February 18–March 9
Walter Quirt, Paintings.

March 10–30
Paintings by Howard Rothschild.
Yves Tanguy. Announcement text by James Thrall Soby (reprinted from *After Picasso*).

March 31–April 21
Early American Folk Art from the Isabel Carleton Wilde Collection.

April 21–May 11
Eugene Berman, Paintings and Drawings. Announcement cover designed by Berman.

May 11–19
Photographs by Eugène Atget. An Epoch of Contrasts: Paris Chateaux, Chiffonneries, Petites Métiers (sic).
Modern Photography.

1936–1937

September 18–October 27
Jacques Bonjean Collection of Paintings: Christian Bérard, Eugene Berman, Leonid, Pavel Tchelitchew.

October 28–November 17
Giorgio de Chirico, Paintings and Gouaches. Announcement cover illustration by de Chirico, essay by Dr. Albert C. Barnes.

November 18–December 8
Max Ernst, Exhibition Surrealist (sic). Announcement poem by Paul Éluard.
Leonor Fini. First solo show in the United States. Announcement essay by Giorgio de Chirico, poem by Paul Éluard.

December 10, 1936–January 9, 1937
Salvador Dalí. Announcement designed by Dalí, with two folding pages reproducing every painting in the exhibition.
In December, a film matinee at the gallery featured Marcel Duchamp's *Anemic Cinema,* Man Ray's *L'Étoile de Mer,* and Joseph Cornell's *Goofy Newsreels* and *Rose Hobart.*
Also in late 1936, Julien Levy's *Surrealism* was published by Black Sun Press.

January 12–30
Rufino Tamayo, Paintings. Announcement cover illustration by Tamayo, text by Luis Cardoza y Aragón.

February 1–20
Leonid, Drawings.
Ferdinand Springer, Paintings.

February 23–March 15
Kristians Tonny, Drawings and Prints. Announcement cover illustration by Tonny, essay by Glenway Wescott.

March 16–April 5
Paintings by Eugene Berman. Announcement cover illustration by Berman.

April 13–May 5
Paul Strecker, Paintings and Drawings. Announcement cover illustration by Strecker.

1937–1938

October 6–November 1
Review Exhibition at Our New Address:
Berenice Abbott, Eugène Atget, Christian
Bérard, Eugene Berman, Massimo Campigli,
Henri Cartier-Bresson, Salvador Dalí,
Giorgio de Chirico, Max Ernst, Walker
Evans, Alberto Giacometti, Leonid, Mina
Loy, George Platt Lynes, René Magritte,
Man Ray, Nadar, Isamu Noguchi, Walter
Quirt, Rufino Tamayo, Yves Tanguy,
Pavel Tchelitchew, Kristians Tonny.
Collage of past announcements reproduced
on announcement cover.

November 2–22
Portraits by Pavel Tchelitchew.

November 24–December 14
The Eternal City by Peter Blume. Detail of
the work reproduced on announcement.

December 15–31
Giorgio de Chirico.
Ballet Caravan Collaborators: Paul Cadmus,
Karl Free, Keith Martin, and Charles Rain.
Announcement essay by Lincoln Kirstein.
Pioneers in Modern French Photography.

January 4–18, 1938
René Magritte, Paintings.
Psychopathic Ward Painting and Drawings
by Bernard Sanders. Pen-and-ink drawing by
Sanders reproduced on announcement.

January 11–25
Paintings by Robert Francis.

January 18–February 1
Paintings by Pierre Tal-Coat.

February 1–19
Alicia Halicka, Assemblage.
Paintings by Leonid.

February 9–27
Paintings by Florence Cane.

March 8–April 3
Old and New "Trompe l'Oeil": Anonymous
Master, Balthus, Evaristo Baschenis, Eugene
Berman, Battista Bettera, F. G. da Bibiena,
Carlo Carloni, Salvador Dalí, Giorgio de
Chirico, Marcel Duchamp, Duvivier,
Max Ernst, William Harnett, Willem Claesz.
Heda, Samuel van Hoogstraten, René
Magritte, Claude Monet, Pierre Roy,
Sequeiros (*sic*), Pavel Tchelitchew, David
Teniers the Younger, G. B. Tiepolo,
Tradition of Arcimboldo. Announcement
essay by Julien Levy.
Marcel Duchamp's film *Anemic Cinema*
(announced as *Spiral*) was screened daily at
five o'clock during the exhibition.

March 15–April 5
Marc Perper.

April 5–May 1
Constructions in Space: Gabo.

1938–1939

September 15–October 4
First National Showing and Sale of Original
Watercolors from Walt Disney's *Snow White
and the Seven Dwarfs.* Disney illustrations
reproduced on announcement.

September 26–October 4
Paintings by Gracie Allen. Announcement
text by Allen.

October 11–24
Honore Palmer, Jr., Paintings.

October 25–November 1
Phenomena by Pavel Tchelitchew.

November 1–15
Frida Kahlo, Paintings. First solo show.
Announcement essay by André Breton.

November 15–26
Maud Morgan, Paintings. First solo show
in New York.

November 29–December 13
Marla Lednicka, Sculpture.

December 8–23
Ione Robinson, Drawings.

December 13, 1938–January 3, 1939
Documents of Cubism: Maria Blanchard,
Georges Braque, Serge Ferrat, Albert Gleizes,
Juan Gris, Henri Laurens, Fernand Léger,
Louis Marcoussis, Jean Metzinger, Pablo
Picasso, Gino Severini, Leopold Survage.

December 29, 1938–January 9, 1939
Exhibition of Recent Work from the Paris
and New York Ateliers of the New York
School of Fine and Applied Art.

January 4–17
Recent Paintings by Abraham Rattner.
Announcement essays by John Dos Passos
and Maurice Raynal.

January 17–February 7
Massimo Campigli.

January 24–February 7
Murals by Jared French. Three murals by
French reproduced on announcement.

February 7–27
Eugene Berman, Recent Paintings, and
Mural Decoration for the House of Wright
Ludington in Santa Barbara, California.
Announcement cover designed by Berman,
text by Julien Levy.

February 20–March 6
I. Rice Pereira. Lighting by Feder.
Announcement essay by William Lescaze.

February 28–March 14
Leonor Fini.

March 7–21
Frede Vidar, Paintings.

March 21–April 17
Salvador Dalí. In conjunction with Dalí's
Dream of Venus pavilion at the 1939
New York World's Fair. Announcement
cover designed by Dalí, with reproduction
of *La Sphere Attaque la Pyramide*, a variation
on the symbol of the World's Fair.

Exhibition of the Original Watercolors
on Celluloid Used in the Filming of Walt
Disney's *Ferdinand the Bull*.

April 18–May 8
John Atherton, Paintings. First solo show.
Remo Farrugio, Paintings (Federal Art
Project).

May (?)
Sheldon Dick, Tri-State U.S.A.:
Photographs of Missouri, Kansas, and
Oklahoma miners.

June 12–16
Mural by Lloyd Goff for Cooper, Texas,
post office. Announcement foreword
by Henry Schnakenberg. Exhibition courtesy
Treasury Department Art Projects.

Summer (?)—September 11
Group Exhibition: John Atherton, Christian
Bérard, Eugene Berman, Peter Blume,
Massimo Campigli, Salvador Dalí, Giorgio
de Chirico, Max Ernst, Leonor Fini, Leonid,
René Magritte, Pavel Tchelitchew.

1939—1940

October 17—30
Color Abstract Photograms by
Nicholas Haz.
Walter Quirt, Colored Drawings.

November 1—11
Bertram Goodman, Paintings.

November 7—18
Gabor Peterdi, Paintings. Announcement
cover illustration and text by Peterdi.

November 14—December 4
Dr. Marion Souchon, Paintings.
Announcement cover illustration by
Souchon.

November 21, 1939—January 9, 1940
Leonid.

December 6, 1939—January 9, 1940
Joseph Cornell, Exhibition of Objects.
Announcement designed by Cornell, essay
by Parker Tyler.

January 9—22
Marshall Glasier, Paintings.
Charles Norman.

January 23—February 25
A Decade of Painting, 1929—1939:
John Atherton, Christian Bérard, Eugene
Berman, Peter Blume, Massimo Campigli,
Salvador Dalí, Giorgio de Chirico, Max
Ernst, Leonor Fini, Jared French, Alberto
Giacometti, Leonid, René Magritte, Matta,
Milena, Maud Morgan, Richard Oelze,
Gabor Peterdi, Joseph Pollet, Abraham
Rattner, Pierre Tal-Coat, Yves Tanguy,
Pavel Tchelitchew, Kristians Tonny.

February 26—March 17
Joseph Pollet, Paintings.

March 5—19
Maurice Grosser, Paintings. First solo
show in New York.

March 19—April 9
Paintings and Portraits by Milena. First solo
show in the United States. Announcement
cover illustration by Milena, text by
Georges Duthuit.

April 6—15
Robert Francis, Drawings.

April 8—23
Original Watercolors for Walt Disney's
Pinocchio.

April 9—23
Surrealist Paintings by Wolfgang Paalen.
Announcement designed by Paalen.
First solo show in the United States.

April 16—May 7
Matta. First solo show.

April 23—May 7
Drawings, 1925—1940, by Pavel Tchelitchew.

May 7—29
Theodore Lux Feininger. First solo show.
Ben Shahn.

1940–1941

October 17–November 9
Recent Paintings, Tennessee and Alabama,
by Maurice Grosser.

November 12–December 7
Group Show: Photographs by John Clarence
Laughlin, Abstract Sculpture by Theodore
Roszak, Paintings by Enrico Prampolini.

December 31, 1940–January 21, 1941
Old American Theatrical Posters.

January 21–February 10
Paintings by S. C. de Regil.

January 21–February 15
Bernard Sanders, Psychological Portraits and
Other Drawings.

February 18–March 24
Eugene Berman.

March 4–24
Paintings by John Enos.

March 24–April 5
Recent Paintings by Abraham Rattner.

April 7–19
Tamara de Lempicka, Paintings
De Lempicka's *Wisdom* reproduced on
announcement, essay by André Maurois
of the French Academy.

April 22–May 20
Salvador Dalí. Paintings, Drawings, and
Jewels (in collaboration with the duke di
Verdura). Announcement designed by Dalí,
with reproductions of his pen-and-ink
illustrations and featuring an interview by
Felipe Jacinto (pseudonym of Julien Levy).

1941–1942
The gallery travels to California.

December 10–26
Recent Paintings of South America and
Illustrations for Children's Books by Ludwig
Bemelmans. Announcement cover illustra-
tion by Bemelmans.

Terry and the Pirates and Other Drawings
by Milton Caniff. Dragon Lady illustration
reproduced on announcement.

Joseph Cornell, Exhibition of Objects:
Daguerreotypes, Miniature Glass Bells, Soap
Bubble Sets, Shadow Boxes, Homage to the
Romantic Ballet. Fold-out announcement
designed by Cornell.

David Hare, Colored Photographs. First
solo show.

**COURVOISIER GALLERIES, PENTHOUSE
133 GEARY STREET, SAN FRANCISCO**

September 3–15
Surrealism: Salvador Dalí, Giorgio de
Chirico, Max Ernst, Joan Miró, Pablo
Picasso, Pierre Roy, Yves Tanguy.

September 30–October 14
Julien Levy Presents Paintings and Drawings
by Christian Bérard, Eugene Berman,
Leonid, Pavel Tchelitchew.

8704 SUNSET BOULEVARD, HOLLYWOOD

October 15–22
An Important Group of Paintings by
Salvador Dalí from the Collection of the
Julien Levy Gallery.

October 23 (?)–November 2 (?)
Paintings by Tamara de Lempicka.

November 5–17
Julien Levy Presents Paintings and Drawings
by Christian Bérard, Eugene Berman,
Leonid, Pavel Tchelitchew.

November 25–December 7
Surrealist Paintings, Documents, Objects:
Salvador Dalí, Giorgio de Chirico, Marcel
Duchamp, Max Ernst, René Magritte, Man
Ray, Matta, Joan Miró, Wolfgang Paalen,
Pablo Picasso, Pierre Roy, Yves Tanguy.

**11 EAST FIFTY-SEVENTH STREET
(DURLACHER BROTHERS)**

February 3–24, 1942
Recent Paintings and Drawings by Eugene
Berman, and Decorative Mural for a House
in Portland, Oregon (Architect: John Yeon).
Painting by Berman reproduced on
announcement.

March 3–30
Paintings by John Atherton. Painting by
Atherton reproduced on announcement.

April 1–16
Leon Kelly, Drawings.

April 21–May 18
Metamorphoses by Pavel Tchelitchew.

1942–1943

October 13–November 7
Maud Morgan.

December 7, 1942–January 2, 1943
Paintings by Maurice Grosser.

January 12–February 13
Leonid.

42 EAST FIFTY-SEVENTH STREET

March 16–April 5
Matta, Drawings. Announcement designed
by Matta.

April 6–May 4
Jesús Guerrero Galván, Paintings.

May 5 – 25
Max Ernst, Drawings

Opened May 22
Catherine Yarrow, Ceramics.

1943 – 1944

October 5 – 30
The "Picturesque" Tradition in American
Painting of the Nineteenth Century:
William Bradford, Thomas Chambers,
Jasper R. Cropsey, Catherine Davis,
J. W. Hill, J. F. Kensett, George C. Lambdin,
W. M. Lanning, Tomkins H. Matteson,
H. Schroff, Lily Spencer, Thomas Sully,
Jerome Thompson, Charles C. Ward,
A. W. Warren, J. Worthington Whittredge,
Enoch Wilson.

November 4 – 30
An Exhibition of Recent Paintings by
Eugene Berman. Announcement designed
by Berman.

December 7 – 28
Through the Big End of the Opera Glass:
Joseph Cornell, Marcel Duchamp,

Yves Tanguy. Announcement designed
by Duchamp.

December 28, 1943 – January 8, 1944
Xenia Cage, Exhibition of Mobiles. Lighting
by Schuyler Watts.

January 11 – February 5
Rico Lebrun, Paintings and Drawings.

February 8 – March 4
Leon Kelly.

March 7 – 31
John Atherton.

April 1 – 29
Dorothea Tanning. First solo show.
Announcement cover designed by Tanning,
essay by Max Ernst.

April 24 – May 8
Max Ernst. Announcement cover designed
by Ernst.

May 9 – 31
Peter Miller, Paintings. Essay by Robert J.
Goldwater.

1944 – 1945

October 3 – 30
Kay Sage, Paintings. First solo show.

October 31 – November 21
Harold Sterner, Gouaches.

November 21–December 7
Recent Paintings by Morris Hirshfield.

December 12, 1944–January 31, 1945
The Imagery of Chess: Eugene Berman,
Peter Blume, André Breton, John Cage,
Nicholas Calas, Alexander Calder, Mary
Callery, Julio de Diego, Marcel Duchamp,
Max Ernst, Filipowski, Arshile Gorky,
David Hare, Jean Hélion, Antonín
Heythum, Carole Janeway, Leon Kelly,
Frederick Kiesler, Man Ray, Matta, Robert
Motherwell, Isamu Noguchi, Vittorio
Rieti, Kay Sage, Xanti Schawinsky, Kurt
Seligmann, Harold Sterner, Muriel Streeter,
Yves Tanguy, Dorothea Tanning, Ossip
Zadkine, Dr. Gregory Zilboorg. George
Koltanowski, world champion of blindfold
chess, scheduled to play blindfolded simul-
taneous games against Alfred Barr, Jr.,
Max Ernst, Frederick Kiesler, Julien Levy,
Dorothea Tanning, and Dr. Gregory
Zilboorg, with Marcel Duchamp as referee.
Illustration of chessmen by Ernst and
chess diagram by Duchamp reproduced
on announcement.

Closed February 15
Group Show: John Atherton, Christian
Bérard, Eugene Berman, Giorgio de Chirico,
Maurice Grosser, Rico Lebrun, Yves Tanguy.

Closed February 28
Fabrizio Clerici, Drawings.
G. Viviani, Etchings.

March 6–31
Arshile Gorky, Paintings. First solo show.
Announcement essay by André Breton.

April 10–30
Man Ray, Objects of My Affection.
Announcement cover designed by
Marcel Duchamp (from an image in a
Hachenschmied film).

May 8–31
Sculptures and Paintings by Max Ernst.

1945–1946

Closed October 31
Peter Miller.

November 6–30
René Portocarrero, Paintings.

December 4, 1945–January 7, 1946
Leon Kelly, Drawings.

January 8–28
Group Show.

January 29–February 16
Paintings by Maurice Grosser.

February 19–March 9
Howard Warshaw, Paintings, Drawings.

March 19 – April 6
Eugene Berman.

April 9 – May 4
Arshile Gorky.

May 14 – June 8
Gar Sparks, Paintings. Painting by Sparks
reproduced on announcement, essay by
Stuart Davis.

1946 – 1947

October 8 – November 9
John Atherton.

November 9 – December 7
Leonid.

December 10, 1946 – January 11, 1947
Paul Delvaux, Paintings. First solo show
in the United States. Catalogue foreword by
Jan-Albert Govis, Commissioner of
Information for Belgium.

January 15 – February 5
Theodore Lux Feininger, Paintings.

February 16 – March 1
Carl Hall, Paintings.

March 1 – 8
Gorky.

March 18 – April 5
Max Ernst, Microbes and Paintings.

April 15 – May 1
Recent Paintings from Paris by
Victor Brauner.

1947 – 1948

October 14 – November 4
Paintings by Kay Sage.

November 4 – 22
Recent Paintings by Carl Hall.

November 22, 1947 – January 3, 1948
Maria, Sculpture. Announcement essay by
André Breton.

January 6 – 31
Dorothea Tanning.

February 1 – 28
Leonid.

February 29 – March 20
Gorky.

March 23 – April 10
Gianfilippo Usellini, Paintings.

April 10 – May 28
Gar Sparks.
Howard Warshaw.

1948 – 1949

October 15 – 31
Group Show.

October 26 – November 20
Jeanne Reynal, Mosaics.

November 16 – December 4
Gorky, 1905 – 1948. Posthumous exhibition.

December 7 – 31
Reflections Paintings by Herman Rose.
Announcement cover designed by Rose.

January 8 – February 14, 1949
Continental American Group Show.

February 15 – March 15
Paul Delvaux.

March 15 – April 12
David Hare, Sculpture. Announcement
cover designed by Hare.

RELATED EVENTS

Murals by American Painters and Photographers

This exhibition, held May 1–31, 1932, at the Museum of Modern Art, was organized by Lincoln Kirstein, chairman of the Museum's Advisory Committee, who appointed Julien Levy to assemble the photo-murals section. Levy included works by Berenice Abbott, Maurice Brattner, Duryea and Locher, Arthur Gerlach, Joella Levy and Emma Little, George Platt Lynes, William M. Rittase, Thurman Rotan, Charles Sheeler, Stella Simon, Edward Steichen, and Luke Swank.

Modern Films and Music

Sometime in 1932, Levy organized a concert cum screening at his father's apartment at 32 East Sixty-fourth Street in Manhattan. On the program: pianist Paul Nordhoff, playing pieces by Bach, Prokofiev, Chopin, and others; *Sportfilm* by Albert Victor Blum, with music by Hindemith and Prokofiev; *Ballet Mécanique* by Fernand Léger, with music by Milhaud; and *L'Étoile de Mer* by Man Ray.

The Film Society

Founded by Levy in October 1932, the Society had as its goals the study, research, and development of film art. It aimed to present to private audiences exceptional independent films, uncensored and shown in their entirety, which otherwise might not be seen.

Directors of the Film Society were Iris Barry, Henry Hart, Lincoln Kirstein, Levy (president), Dwight Macdonald, Harry Alan Potamkin, Critchell Rimington, Raoul Roussy de Sales, Irvin Shapiro, Louis Simon, and John A. Thomas; counsel was Morris L. Ernst. Sponsors were Sherwood Anderson, Wilton A. Barrett, Norman Bel Geddes, Mrs. Seymour L. Cromwell, Frank Crowninshield, e. e. cummings, John Dos Passos, George Gershwin, D. W. Griffith, Edith J. R. Isaacs, Alfred A. Knopf, Eva Le Gallienne, Henry McBride, Mr. and Mrs. Gilbert Miller, Lewis Mumford, Nelson Rockefeller, Mrs. Paul Reinhardt, Lee Simonson, Leopold Stokowski, Cleon Throckmorton, James Sibley Watson, Jr., and Efrem Zimbalist.

Listed below are the Society's five programs, all held in 1933, the first at the Essex House, the rest at 361 East Fifty-seventh Street, in Manhattan.

PROGRAM ONE: JANUARY 29, 9:00 P.M.

1. *King Neptune* by Walt Disney, animated color cartoon.

2. Brahm's Ninth Symphony (sic),
photographs of light waves produced by
music.

3. L'Opéra de Quat' Sous (1931;
French version of Die Dreigroschenoper /
The Threepenny Opera), by G. W. Pabst. Book
and lyrics by Bertolt Brecht, music by Kurt
Weill. Photography by Fritz Arno Wagner.
Sets by Andrej Andrejeff. Produced by
Warner-Tobis.

PROGRAM TWO: FEBRUARY 26, 9:00 P.M.

1. The Lamb (1918). With Harold Lloyd
and Bebe Daniels.

2. Laughter (excerpt) by H. d'Abbadie
d'Arrast. Dialogue by Donald Ogden
Stewart. With Nancy Carroll and Fredric
March.

3. Three abstractions
Ballet Mécanique (1924) by Fernand Léger.
Lichtspiel (1932) by László Moholy-Nagy.
First showing in the United States.
Commercial Medley (1933) by Lewis Jacobs.

4. Pearl of the Army, Episode 5 (1916).
With Pearl White.

5. L'Affaire Est dans le Sac (1932) by
Pierre Prévert. Scenario by Jacques Prévert.
Produced by Pathé-Natán, Paris. First show-
ing in the United States.

PROGRAM THREE: MARCH 19, 9:00 P.M.

1. Mail, Russian animated cartoon.

2. Athletic Movements Analyzed, early
slow-motion picture.

3. L'Âge d'Or (1930) by Luis Buñuel.
Scenario by Buñuel and (credited to)
Salvador Dalí. With Gaston Modot and
Lya Lys.

PROGRAM FOUR: APRIL 23, 8:30 P.M.

1. Paths to Paradise (1924) by Clarence
Badger. With Raymond Griffith and Betty
Compson.

2. Nesting of the Sea Turtle (1929).
Documentary by Floyd Crosby and Robert
Ferguson.

3. Trees and Flowers (1933) by Walt
Disney. First animated color cartoon.

4. Applause (1929) by Rouben
Mamoulian. Book by Beth Brown, adapted
by Garrett Ford. Photography by George
Folsey. Produced by Paramount.

PROGRAM FIVE: MAY 17, 9:00 P.M.

1. The Unlucky Truck, Russian animated
cartoon.

2. Sex Life of the Polyp (1928) by
Robert Benchley.

3. Le Sang d'un Poète (1930) by Jean
Cocteau. Music by George Auric. Photog-
raphy by Georges Périnal. With Lee Miller.

Paintings by Max Ernst

This exhibition, held November 23–
December 11, 1948, at the Knoedler gallery
in New York, was arranged in conjunction
with Levy's gallery.

Index

Page numbers in bold italics refer to illustrations; N refers to Notes sections.